Another Brush with God

other Brush
—with—
GOD

ther Conversations about Icons

Peter Pearson

Morehouse Publishing
NEW YORK · HARRISBURG · DENVER

Morehouse Publishing, 4775 Linglestown Road, Harrisburg, PA 17112

Morehouse Publishing, 445 Fifth Avenue, New York, NY 10016

Morehouse Publishing is an imprint of Church Publishing Incorporated.

Cover art by Peter Pearson

Cover design by Corey Kent

Interior design by Beth Oberholtzer

Library of Congress Cataloging-in-Publication Data

Pearson, Peter (Peter F.)
Another brush with God : further conversations about icons / Peter Pearson.
p. cm.
Sequel to: A brush with God.
Includes bibliographical references.
ISBN 978-0-8192-2298-5 (pbk.)
1. Icon painting—Technique. I. Title.
N8188.P428 2009
751.45'482—dc22

Printed in the United States of America

09 10 11 12 13 14 10 9 8 7 6 5 4 3 2 1

———————

This book is dedicated to all my students,
who have taught me so much and who have
welcomed me as a friend. This is a journey
of paints and brushes, but much more it is a
journey of the heart—so many hearts all aglow
with the light of God's love. We have created
community, prayed and sang to glorify God,
encouraged and loved one another, laughed with
joy, and somewhere in the midst of all this
the image of God has been made manifest.
What a wonderful way to live.

———————

— CONTENTS —

— FOREWORD —

For ages upon ages, Orthodox monks in remote monasteries prayed images of saints into being with egg tempera and brushes. They breathed halos of gold leaf into shimmering existence onto wood panels. They could and sometimes would spend months or possibly years moving garments from darkness to light, creating layers of feathers on angel wings. No need to rush. Iconography was prayer, another way to rejoice in the communion of saints even though paints and brushes were involved. It still remains all that, but you don't have to disappear from secular life to have what Peter Pearson wisely calls "a brush with God." These days, you can easily attend classes with any number of contemporary iconographers. Peter is one of them, and I'm an enthusiastic fan for a number of reasons.

His icons are brilliant in every sense of the word. As a matter of style, Peter's icons are traditional yet fresh, neither totally Greek nor totally Russian. I've long characterized them as being uniquely American, without being overly Westernized. Please don't miss any opportunity you may have to sit quietly in prayer with his icons. They are, as noted on the back of the board, "by his hand," but clearly painted by the grace of God.

Peter is a gifted teacher who has democratized contemporary iconography. You're turning the pages of beautifully clear evidence in your hands right now. His teaching methods and style make iconography simple, albeit not easy. Here, in his second book, *Another Brush with God*, you'll find detailed instructions for painting icons with traditional images as well as guidance for creating an icon image of your own favorite saint.

He teaches, both in person and in writing, that anyone called to do so can learn how to paint icons. Why should iconography belong to a privileged group of monastics or artists? It is, after all, much more than an esoteric art form. It's a venerable spiritual practice that just so happens to involve art media. Having formal art training may, in fact, be a liability. Peter encourages aspiring iconographers to understand how prayerful intentionality trumps artistic prowess—there's absolutely no reason to become the terrified hostage of templates and tracing paper, pencils and inking pens, paints and gold leaf. He also challenges the dogmatic use of painting medium, taking the somewhat iconoclastic, so to speak, position that acrylic can be used just as prayerfully and effectively as egg tempera.

At the same time, Peter makes a case for learning and respecting established rubrics for image and color in iconography. In his narrative text and through anecdotal asides, he explains how this structured process actually frees you to engage more deeply with the image. He encourages you to prayerfully discover how, for example, painting the tiny details of an arm, a garment, a distant landscape can generate big questions: Why this? How can I ponder what's next without rushing to get there?

And I'd be totally remiss if I failed to point out that Peter is a lot of fun. It doesn't matter whether he's facing challenges on the icon board or in life, which now includes serving as the rector of a small but growing Episcopal parish. Peter approaches all of it as both teacher and student, with admirable modesty and great good humor. He delights in all things, sees God in all things, and in this book invites you to do the same.

Feast of Saint Cyril and Saint Methodius, February 14, 2009
Meredith Gould, PhD

— PREFACE —

In my first book, *A Brush with God*, I provided the basics of iconography: line, color, and prototypes, as well as commentary about the history, spirituality, and meaning of this ancient form of prayer. So here I am, a few years older, living on the other side of Pennsylvania, juggling life as an iconographer and teacher with a new set of responsibilities as the priest of a small parish in New Hope, Pennsylvania. I love the variety and diversity of my life; I love the preaching and the presiding and the teaching and the painting. I love the people I serve in every part of my life, and I love the fact that I am living my passions, all of them, every day. How fortunate and blessed can one person be?

My first book—and it's really odd to write that because I never thought I'd write *any* books—has done well and no one is more surprised than I. In some ways, that has made writing this book much more challenging. I kept thinking about all the *Rocky* movies and the fiasco of *Jaws 2* and the obvious fact that sequels don't generally do well. Talk about pressure, but that's exactly the kind of stuff I'm always telling others to ignore. I was hearing the voice that sometimes tells me I have no right to pick up a brush to paint icons. And I know this is certainly not the voice of God, so after a few months of mental flailing around, I told myself to shut up and write. Not exactly your typical prayer but oddly enough, the words and ideas started flowing, and here we are.

In this new book, I build on the foundations laid down in *A Brush with God*. You'll find step-by-step instructions for several icons that will provide opportunities for you to practice painting landscapes, architecture, and musculature, as well as applying patterns to garments. You'll also find instructions for constructing a drawing based on principles of sacred geometry, as well as drawings by several iconographer friends and me.

I've provided tips that will enable you to tackle any icon with confidence. Practically speaking, the technical skills I teach in this text can be combined in an infinite variety of ways. Indeed, I hope you'll discover that you are more confident and capable of understanding new skills, although I do want to remind you that understanding is not the same thing as mastery. Head knowledge can only be put into practice and refined by picking up a brush and painting, so I hope you'll do exactly that.

Perhaps the best way to read this book is to have several books, catalogs or icon calendars sitting somewhere nearby that you can grab easily. These resources can be collections of good quality prints of icons from any school and time period because you will always find examples of the things I am referring to if they are truly Byzantine icons. There are many variations on the theme but they share a strong connection to one another because of the canons that have been handed down from teacher to student over the centuries. Don't be afraid to do some work here because that will only serve to reinforce your knowledge and grasp of this subject. It seems like a good way to teach from where I sit because without this effort on your part you may not really learn, having had too much simply handed to you. So roll up your sleeves, gather the resources and get to work!

Above and beyond all the technical details, my prayer for you is that using this book will inspire you to fall in love with iconography all over again, reengaging with this ancient discipline that will enrich you for many years. I hope you'll discover how painting icons helps you to pray more deeply and that by painting the saints, you become more saintly. I believe iconography has done that for me in many respects. Although I wouldn't describe myself as a stereotypically pious person, I'm a man of deep faith who loves God, who tries to discern God's will in my life, and then strives to get beyond my own stuff enough to let God's will flow through me. I love the anecdote about how Vladislav Andreyev stood behind a student frozen with self-doubt and whispered, "Too much you, not enough God." Maybe the best thing you can discover about yourself while painting icons is that you really aren't the center of the universe—a lesson I seem to need to relearn every few minutes.

This afternoon as I write, I pause every so often to look out my window at the monastery of the Society of Saint John the Evangelist (Cowley Fathers) in Cambridge, Massachusetts. My view takes in the Charles River glistening in the golden light of early fall. It's beautiful. It's quiet. I've been able to step out of my regular routine to see what else I can glean from my experience to share. And here we are.

Blessings,
Peter

ACKNOWLEDGMENTS

There are so many people to thank who helped behind the scenes to create this book as well as the first one:

- Dennis Stefan of Dublin, Ireland, my old friend and neighbor from Pittsburgh, helped to make the photos presentable.

- Jody Cole, Marek Czarnecki, Diane Hamel, Wayne Hajos, Father Damian Higgins, Charles Lucas, and Kathy Sievers shared some of the sketches offered here to further your painting.

- Meredith Gould edited both of my books and seems to have a knack for getting my voice down in print and helping me to understand what I'm trying to say in the first place.

- The good people of my parish, Saint Philip's in New Hope, Pennsylvania, who love me, bless me with the privilege of serving them, and often humor my idiosyncrasies—thanks for allowing me to share what I love.

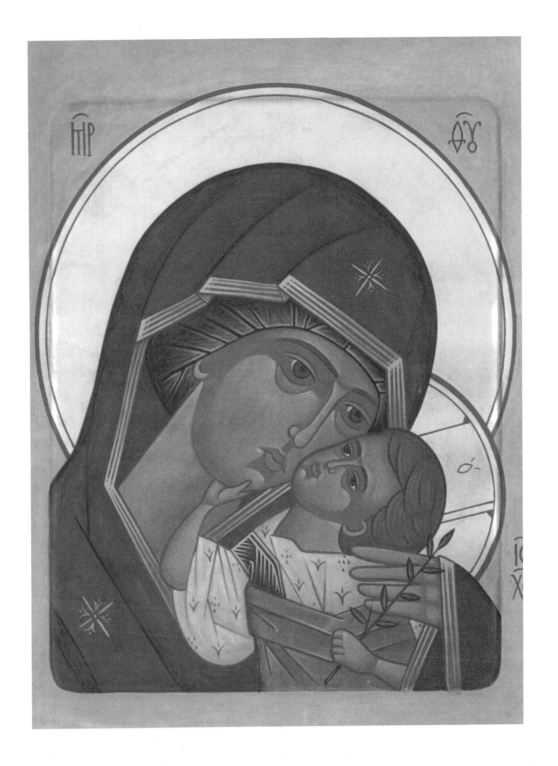

— CHAPTER ONE —
Reflections on Spirituality and Technique

The letter to the Colossians tells us that Jesus Christ is the proto-icon of God made visible—made present to us in the incarnation. This bold statement lies at the heart of understanding the spiritual significance of icons within Eastern churches, where everything that has been created is viewed as good because God created it and we, like Jesus, although imperfect, reflect the image of God into the world. Icons give us a glimpse of the beauty to which we are invited and called. They inspire us to embrace God's love and to be transfigured through our own surrender to God's will. This integrated, holistic way of relating to the world is a primary characteristic of the Eastern church and immediately apparent in the Eastern (Orthodox or Byzantine Catholic) liturgy.

Enter any Eastern Orthodox or Byzantine Rite church and the first things you'll probably notice are the smell of incense, the dimly lit space, and the reflection of flickering candles in the icon's halos. As your eyes grow accustomed to the dimness, images of saints begin emerging from the shadows and appear on almost every surface that could possibly support an image. The church is filled with movement as people visit small podiums decked with lavishly embroidered cloth coverings on which even more icons are displayed. Worshippers kiss the icons and bow and cross themselves over and over again, whether the service has started or not.

An Orthodox woman once approached me to confide, "The East is full of tricks to get you away from your head. When you get into your head, you get into trouble." Her comment reminded me of when I lived outside of Washington, DC, and often visited a small Eastern Orthodox monastery near Catholic University for vespers on Saturday evenings. I began doing this as a Lenten practice and ended up going there regularly to begin my celebration of the Lord's Day. It took a while to become comfortable with the experience, but it happened not by thinking it through, but by simply giving myself up to the experience, by letting myself go. I had become used to the order and linear progressions of the liturgy of the Roman rite, where only one thing happens at a time and everyone stays put until told to move. That simply doesn't happen in an Eastern liturgy.

A whole new level of complexity is added to this already complicated experience once liturgy begins—doors open and close on the iconostasis (icon screen), and people pop in and out of them. Prayers, repeated as often as forty times, offer richly poetic images that come at us too quickly to absorb. Chants bounce back and forth between the choir, the cantors, the priest, the deacon, the reader, and the people. And oddly enough, all this happens simultaneously.

For Westerners, this experience is as unbelievable as it's overwhelming. We often find ourselves unable to take it all in because we try to understand it all, to think it all through, which is impossible because what we're experiencing is a dance—the dance of God. Those of us from Western church tradition are far too heady, far too controlled, and far too self-conscious to allow ourselves to be taken by the dance, no matter whose dance it is. But that's exactly what the spiritual life is unceasingly inviting us to do, whether we've been brought up in Manhattan or Moscow. Yes, the Eastern church has lots of ways to get us out of our heads so we might become whole and holy people who aren't afraid to dance with God.

Many Teachers

I encourage my students to continue studying with a teacher or even several teachers. It doesn't really matter which teacher, or which style they prefer, or what medium they use. Just study. Everything a teacher offers is transformed within and by the student anyway, and emerges as a new development rather than a new entity. Teachers simply enhance the painting we already do and I, for one, can never be enhanced enough.

Over the years, I've been blessed to study with perhaps seven or eight different iconographers and each one has taught me something that has become part of my work. From Charles Rohrbacher, I learned to appreciate the translucence of colors and how to construct a strong initial drawing grounded in sacred geometry. Nick Papas taught me to use fluid paint boldly, to layer colors and infuse my icons with some playfulness. Nina Bouroff helped me to literally touch the earthiness and rich history of Russia by teaching me how to make just about everything from scratch. Phil Zimmerman transmitted a wealth of technical information, taught me to teach, introduced me to color theory in a way that finally made sense, and offered lots of encouragement along the way. Valentin Strelzov inspired me to simplify, to experiment a bit, and trust my instincts. Father Damian shared his profound grasp of the theology behind what we do as iconographers and showed me a great deal about the spontaneity of what knowing the tradition deeply can give birth to. Marek Czarnecki blessed me with his incredible understanding of the process of modeling garments with light and inverse perspective.

I spent a week at Saint Tikhon's Orthodox Monastery in northeastern Pennsylvania studying with Xenia Pokrovsky, her daughter Anna Pokrovskya-Gouriev, and Marek Czarnecki. I learned a

great deal and felt more than a little challenged because they use egg tempera, which I haven't used in years. It was a humbling experience. I felt like I was starting from scratch and recognized in myself the anxiety I often observe in my own students. Even after decades of painting icons, I learned something new. Actually, I learned a bunch of seemingly small things that became exciting revelations.

For example, I learned how the highlights on garments (which they simply call "lights") are in reality more extensive than they appear to be in books. Prints of icons and actual icons are different from one another; even the best reproductions are compromised and cannot compare with originals. I discovered how the first highlight should be big, bold, and transparent, much more so than I had done in the past. The second highlight should be less transparent, brighter, and smaller but painted directly on top of the first. The third highlight is smaller still, very much less transparent, and brightest of all. Plus, my teachers made some exciting color choices, ones I hadn't previously encountered. For instance, when they make dark blue garments they don't begin with a dark blue base; instead they use a gray/green base and highlight it with lighter and lighter shades of blue. How cool is that?

Perhaps more than anything else, I always learn a great deal by simply watching other iconographers paint. It doesn't really matter whether they are masters or not. In fact, I learn from my own students all the time by observing how they hold the brush, the flow of their brush strokes, the subtle and intuitive touches of color here and there, as well as choices they make regarding color composition.

I hope my experiences encourage you to study with any and every teacher you can. Something good will surely come of it even—or especially—if you think you've already learned everything you need to know. There's always more.

PRIEST, PASTOR, ICONOGRAPHER

Speaking of study, because my other vocation as a priest allows me to take continuing education courses, I was able to spend several days at the General Theological Seminary in Manhattan with Elisabeth Koenig, PhD, who offered a course on "The Jesus Prayer and Eastern Christian Spiritual Practice." This was a wonderful way to connect my practice of iconography with deeper learning about the spirituality from which this sacred art form arises.

Before arriving for this two-day intensive course, I received a reading list of about fifteen texts from the Desert Monastics of the Justinian era in the early church, the patristic writers, the compiled works of Eastern monks and mystics in the *Philokalia*, some Western Benedictine perspectives, along with a few modern authors reflecting back on the insights and practices of the past, including praying with icons. During discussions about the Jesus Prayer, the prayer of the heart, I encountered a concept relatively new to me (at least the term is somewhat foreign): discernment.

Discernment means going beyond constant judgments about what we like or dislike, what we want and do not want, and what we think and what we disagree with to seek God's will for us. This

may or may not have anything to do with icons, but it's a huge consideration for the believer. Perhaps this is how discernment matters to us as iconographers, because our first priority, through the work of our hands, is to invite others to the transformation that can come from a life of prayer and service. Each of us is called to conversion, to be renewed and reformed into the image of Christ, the proto-icon of God. As iconographers, we have an amazing opportunity to participate in gathering others into relationship with God—if we can get our own egos out of the mix.

As an iconographer and as a priest, I marvel at how I serve best when I don't think about how I'm doing but simply do what's before me as well as I can. Being a priest and an iconographer, or a retired person, a teacher, a farmer, a nurse, a football coach, or a lawyer can all be a means of personal conversion and service to others. The trick is to do our work in such a way that points our hearts and the hearts of those around us to the heart of God.

God's grace can do amazing things; all we have to do is simply get out of the way. The most powerful icons do just that—they get out of the way even as they engage us and point our hearts toward God. Iconographer Vladislav Andreyev insists that the primary rule of iconography is that the icon be so transparent (that is, not drawing attention to itself) that it has no other role but to move you closer to God. Now that's egoless transparency! Consider this: We live in a time and a society in which almost nothing invites us to let go and to trust God. We trust in many things, but God is not usually our first choice.

PAINTING BIG

Recently I've been surprised to learn something so obvious that I totally missed it for years: There's a huge difference between the way you paint large, public pieces, the way you paint medium-sized icons for chapels or homes, and the way you paint small, personal icons. Imagine that.

A few summers ago, one of my students and I replaced a number of wall panels for a church in Pittsburgh. Each panel was about nine feet high and three feet wide. We were recreating originals destroyed by water damage in the apse area of the church about twenty-five to thirty feet up and approximately several hundred feet from the first pew. As we began measuring the areas, we noticed that the surviving panels were quite rough and very "impressionistic" in their style. We tried to emulate the boldly confident brush work of the original master artist, Jan De Rosen, and although we made a valiant effort to approximate his boldness, we simply could not prevent ourselves from working as if we were doing the usual 9 x 12 or 12 x 16 inch panels. Although the panels we created did the job they were intended to do, our work lacked the confidence, playfulness, and drama of the artist we tried copying. We added too much fussy detail when we should have concentrated on the effect

from a distance. Lots of what we had spent hours on disappeared once we came down from off the scaffolding. That was a real awakening for me.

On the other hand, students who have painted with me on smaller panels in classes have heard me tell folks to step back now and then to see how the icon *really* looks, because things that look like a big deal from four inches away really aren't that significant from three feet. It's obvious when you're working on a small panel that you need to get away from it to see it clearly. It's the old "three-foot rule," meaning that if it looks good from three feet away, it's okay.

Similar wisdom applies to painting big for church-sized images that will not be seen from up close by anyone but the person who restores it one hundred years later. Step back and see how it will look from the distance of those who will regularly look at the images. In other words, evaluate whether you have done enough or too little in context. Whether you're painting a very small icon or a large mural, you begin eliminating detail or at least minimize the fussy small stuff that a medium-sized icon would include. On small icons, faces become a bit simpler and highlights become a bit more restrained. On the other hand, very large images require bold brush strokes and less refined or less subtle layering. You allow the eye to do the blending for you rather than painting subtle transitions of color from layer to layer. There should probably be at least three classes for icon painters: miniatures, average-sized icons, and large, mural-type painting techniques. Each demands its own approach and understanding of how the icon will be viewed as well as experienced.

Beginning Again

If you take out any book of good quality prints of old icons and spend some time examining the images before you, you'll immediately notice the strength of the composition in each icon that made it into the collection. This excellence doesn't happen by accident or by believing a weak design will somehow work itself out in the painting process. Masters spend time with the design before they ever touch brush to panel, so begin with a good, clean drawing that's well thought-out and intentional in every respect. When you edit or finalize your drawing, keep it simple. Don't add a line for every subtle fold or highlight. Simplify your drawing over and over until you have found the essence of the design. Obviously a drawing can be too simple, but I find that students more often err on the side of too much information in their drawings as well as in many other parts of this process.

For each color area, figure out what base color to use, since it's the main color before any highlights or shadows are added. Skilled iconographers in earlier times did not create lots of fussy little areas, each with its own shade of color. Base colors were rather simple. A mountain was one color. A robe was one color. Faces and hands and feet—actually the whole body—was one color. Study until you can see where the base colors go and note how the same base colors are repeated throughout the image to give unity to the icon.

The main base color areas are then sometimes shadowed a bit to enhance the basic color and give it some interest. Before you begin, study your prototype a while longer. Sometimes what can initially look like a shadow is merely the effect of the highlights on the base color areas that remain untouched.

Although the overall process is a layering of colors from dark to light, now and then shadowing is utilized. You can really see this on the sides of mountains and buildings. It can also become apparent on garments after a bit more examination. This is sometimes achieved by adding shadows on the drawing itself before any base colors are added. (See illustrations of the Saint Peter icon that I recreated using the technique of egg tempera painters on page 81.) In this case, base colors must be layered onto the drawing very transparently so the shadow will show through. If you do not put the shadow on the drawing at the beginning, it's possible to add a hint of shadow using a wash of a darker color, or perhaps a complementary color, but be very careful not to overdo it.

Next, it's time for the highlights. A thorough study of an old prototype should reveal the layers of highlights that were applied to create the sense of blending or the transition from darker base colors to light areas. The "hardness" or "softness" of these transitions varies depending on the school, the century, and the amount of influence Western art has had on the icon you're studying. Remember, too, that some icons were created for intimate, personal prayer and some were painted for large, public, liturgical spaces, which means they were viewed from significant distances.

So what about mistakes? They seem to be beginners' greatest fear and obsession; mine too at times. In my better moments, I realize my mistakes are some of my best teachers. No one wants to make a mistake on an icon that has already consumed hours of painting but sometimes that's just the way it happens. The significant question is not whether we make mistakes but whether we learn from them.

Every icon I paint is hopefully the best icon I can do at that moment—my mistakes almost guarantee this if I'm paying attention. But paying attention is the tricky part and does not happen automatically. We must stay awake in the spiritual and physical sense, focus on more than simply producing an icon, and remain teachable. This might seem like a no-brainer, but actually doing it is far more difficult than it might seem.

I've found there are usually at least three layers of highlights in iconography—that's three layers of lighter and lighter color. Any of these colors might be applied just once or may be applied in translucent layers, gradually building the intensity of the color.

Details and ornament are usually added at the end so you don't have to paint around anything. Spears, crosses, embroidery, headbands, patterns or ornaments on garments, small vegetation, and even calligraphy are all elements that can easily be added on top of the highlighted base colors after

all the big work is completed. As an aside, one thing I've noticed about what separates beginners from more skilled iconographers is that beginners often get lost and overwhelmed in the details. Most details come at the end of the process rather than at the beginning. Go from big to small or from general to specific. That seems to work well for me. Besides, that's the way God created the universe. Check out the creation stories of Genesis and follow God's example.

As iconographers, we paint because we love to paint but also because we seek a sort of intimacy with God, with Jesus, with Mary, the angels, and the saints. We do this for ourselves in a sense, but this closeness to the holy ones overflows in service to others as well. I'm fond of saying that when we are at our best, we are also at our best for others. Spending time in the company of good people, especially saintly people, always makes me feel like a better person. This also happens when I paint icons. I always read about the persons I'm depicting and try to absorb a bit of who they were while they still walked among us. That might involve reading their biography or some fragments of their writings. But there is another sort of knowing that comes from painting the faces of these holy ones. It involves the knowing that comes from learning *about* them, but also the knowledge that can only come from looking into their eyes. Iconographer William McNichols says that if we spend our lives gazing upon the faces, into the eyes of these holy ones, how can we help but become more holy and wholly compassionate ourselves? It's a question of knowing, of allowing ourselves to become saturated with the one we depict.

SPEED AND NOISE

In many monasteries a visitor will encounter a sign that reads, "God Alone." To some folks, this may sound foreboding and lonely, but it needn't be. It's not a cerebral experience nor is it one of painful solitude. It's just life lived intentionally and well.

One of the most wonderful years of my life was my novitiate at Saint Vincent Archabbey in Latrobe, Pennsylvania. I'd come from a very busy life in Washington, DC, where I owned a small business, was active in my parish, studied at Georgetown University, enjoyed an active social life, and painted icons in my spare time. Coming to the monastery was like slamming on the brakes while driving sixty miles per hour. It certainly was a jolt. But once my eyes stopped spinning and the novelty wore off, I adjusted to the pace. It was almost luxurious. Life was simple: Pray, work a bit, study a bit, eat, sleep, and paint. There were no bills to pay, no deadlines to meet, no urgent demands on my time or energies. We, the novices, couldn't go anywhere and we couldn't mingle with the others except in limited instances, so there was lots of down time. For an entire year of my life, I enjoyed the blessings of

undivided focus on the things that matter in life and I had them with some sense of proportionality to the necessary demands of life. As you read this, you can almost hear me exhale deeply as I remember that year. It was wonderful.

During that year I had the time and ability to paint in silence—internal as well as external. My technical skills as well as my interior sense of what we, as iconographers, are about grew at an amazing rate. With nowhere to go and nothing to do, I could give myself to the moment, to the painting, and to the profound processes that enveloped me on every side.

You don't have to go off to a monastery, quit your job, or leave your family and friends behind to become still. Sometimes we just have to give ourselves what we give kids when they've gone over the top: a time-out. Only then can we reflect on what's important and whether we want to continue doing things the way we have been doing them. Speed and noise are not our friends—at least not all the time. I suspect the same is true for the vocation of the icon painter. As a teacher of this discipline, I can testify to the fact that some of my best students come into the classroom, sit down, pick up the brush, and work quietly but deliberately. Those are the ones who shine without even trying. On a number of occasions, I've been blessed to teach entire groups of people for whom chatter was the exception rather than the rule. In every instance we were able to tackle moderately complex images in short amounts of time without much anxiety or drama. No one attempted to become a master in one sitting or to turn the whole experience into a coffee klatch with paints. We painted, we prayed, we let go, and we learned. It's amazing what you can do with undivided focus.

Iconography is a way of prayer, a way to get to know God better that can't happen unless you're willing to sit still and be present to the moment, which is the only place to find God. Right here and right now: Sit down, be quiet, pick up a brush, do your best, and let God do the rest. Like they say in the monastery, "God alone."

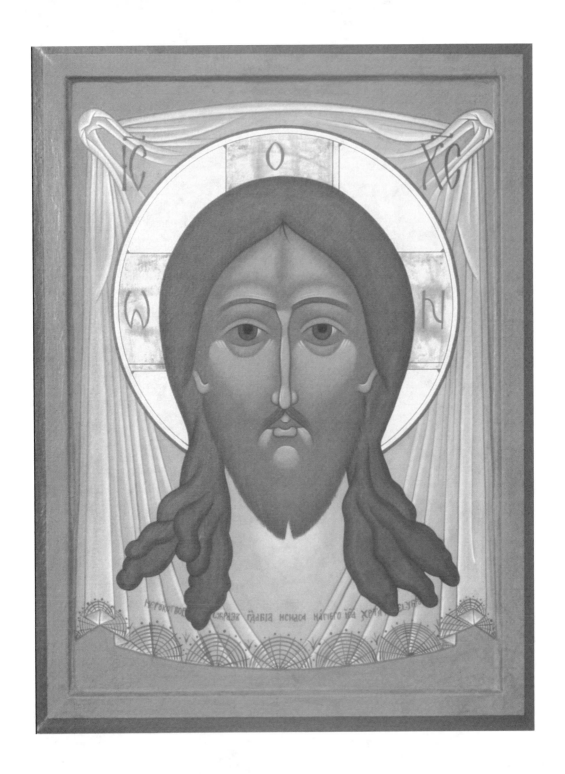

Painting Heads

Almost anyone familiar with iconography will tell you the face is a priority in every icon and the eyes are the way to enter the soul. This is where you really have to pay attention. Faces in Byzantine icons are strong and noble, completely free of any emotion (except in icons of the Crucifixion and Entombment). They beckon the viewer to come closer, to engage with the image and become transformed by the encounter. In most icons, faces are viewed from either a full frontal or a three-quarter angle. Much of this is determined by the scene being depicted and the role of the person within that scene.

Over the years, I've taught inverse perspective, the strangely idiosyncratic ways in which icons show objects getting bigger as they move away from the viewer as opposed to the more natural perspective in which object get smaller as they move into the distance, as an integral part of the way landscapes and architecture are laid out in iconography. Oddly, it was not until recently that I finally realized that the same inverse perspective is at work in the way the head of a figure is constructed in an icon showing the front, sides, and top of the head all at one time. While sitting in Xenia Pokrovsky's lecture on faces and heads, watching her deconstruct an image of Saint Nicholas, I finally saw it even though I had been looking at these images for forty years. Heads in icons, like the furniture, get bigger rather than smaller as their parts move away from the viewer! Wow, am I slow.

You'll rarely find a face in profile in an icon unless the painter is making a statement about character that's not at all flattering. People rendered in profile are usually viewed as sinister, ignorant, or enemies of God. Naturally, for every rule in icon painting there are lots of exceptions. You can find, for example, a number of Russian images of the Last Supper (Mystical Supper) where the iconographer put some of the apostles in profile so that they could be seated around the table. (For Westerners who view DaVinci's *Last Supper* as the model, this will seem unfamiliar, but the icon represents a more authentic image of how that meal was experienced.) For the most part, people in icons are rep-

resented facing out rather than in profile. When profiles are used, the renderings always seem a bit clumsy. Unlike the ancient Egyptians, iconographers were not skilled in this manner of rendering.

THE HEAD AND FACE

Frontal

The frontal pose is almost always used in icons with a single figure or a group of saints or angels when no narrative is being communicated. These instances offer viewers a direct and complete experience of the people depicted. It's a face-to-face encounter within which we experience a directness and intimacy that leads us first to the eyes, then beyond them into the soul of the person portrayed and ultimately to God. Rarely do hands cover the face. Occasionally, you'll see a hand placed on or near the face as a gesture of grief or silence, but these are the exceptions rather than the rule. Images of those in glory have a directness and an unassuming openness that would only be compromised by emotion or gestures drawing our attention away from this saint and the God upon whom they gaze.

As you look through catalogs of old icons, rarely will you find a totally symmetrical, full frontal rendering of a face. The rigidly full frontal rendering can be uninspiring, uninteresting, and predictable. One striking exception is the Archierpoitis Christ from Kiev, which is frequently included in texts about icons. There's a remarkable power in this icon and if you look closely, you'll see how while the face is frontal, it's not slavishly balanced or symmetrical. Faces rendered from the front are often skewed ever so slightly to one side or the other. Again, look closely and you'll discover that the parts of the face are not consistent; some elements lean to the right side and others to the left. Seeing this may take some time and concentrated effort, but there are many examples, especially in Russian icons of the eleventh to fourteenth centuries. Looking closely can teach you many things.

Three-Quarter

The three-quarter view is commonly seen in icons with several figures grouped around a central focus, such as in the icon(s) of the Diesis, where angels and saints flank the image of Christ, or where the prophets are arranged around the image of the Mother of God. This type of rendering is also used in festal and narrative icons depicting either a scene from Scripture or the life of a saint. For the image to work, some figures have to be in relationship to another element within the icon. By doing this, the whole composition is more visually believable as subtle gestures of certain figures focus our attention toward the primary person or action taking place.

Note that the term three-quarter view isn't meant to be mathematically literal but rather an angle somewhere between full frontal and profile. Later, I'll describe how to construct both the frontal and three-quarter view using the geometric principles used by the ancient masters.

SKIN TONES

Since icons show human beings, albeit glorified ones, and angels represented anthropomorphically, you can't avoid learning how to paint skin tones. This can get complicated because skin color varies widely throughout the human family, although ancient icons rarely addressed racial differences. Today, however, we celebrate diversity within the human family in our images of faith. Also, now that we have photographic images of more recent saints, their icons need to be true to what they looked like in life, including their racial identities.

Caucasian and Middle Eastern

The most common type of skin tone represented in iconography is that of people from Caucasian and Middle Eastern backgrounds. This skin tone is created by beginning with the sankir/proplasmos skin mix as the base color, which can be created to range from an olive green to a muddy brown. (In the step-by-step instructions in chapter 7, I have given several different recipes for the base color for skin.) Although the base color might seem dark, it's important to remember it's the shadow tone. The overall look of the figure will be lightened by the addition of highlights. On top of the base color, lighter shades of color are applied to "flesh out" the figure. I usually use shades of yellow ochre to achieve this highlighting. My first highlight is painted with yellow ochre mixed with a bit of red to create an orange, the next is just yellow ochre, and then I add white until I achieve the desired effect.

13

African and Aboriginal Skin

You'll need to start with a significantly darker base color to create darker skin tones for people with African and aboriginal origins. I recommend using a dark brown, although manuals from the Middle Ages note that sometimes deep blue would work to achieve the look of dark skin. I have not tried this technique, but it has interesting possibilities. Generally I use a color like burnt sienna (a beautiful chestnut color that is basically reddish brown) for the first highlight and then lighten that color with another color, such as yellow ochre, and then finally add some white to paint the last few layers. I do not want to limit your options here. Go ahead and experiment with a variety of colors for both base tones and highlights to discover what works best for you. As far as I know, there's nothing canonical about how you get there.

Asian and Native American

Asian and Native American skin tones are perhaps the most challenging of all to paint because of very subtle differences in the skin color. [As we know, they are closely related on the genetic level due to migration across the Bering Straits thousands of years ago. About twenty years ago, I painted an image that incorporated several Native Americans and was able to create believable likenesses by

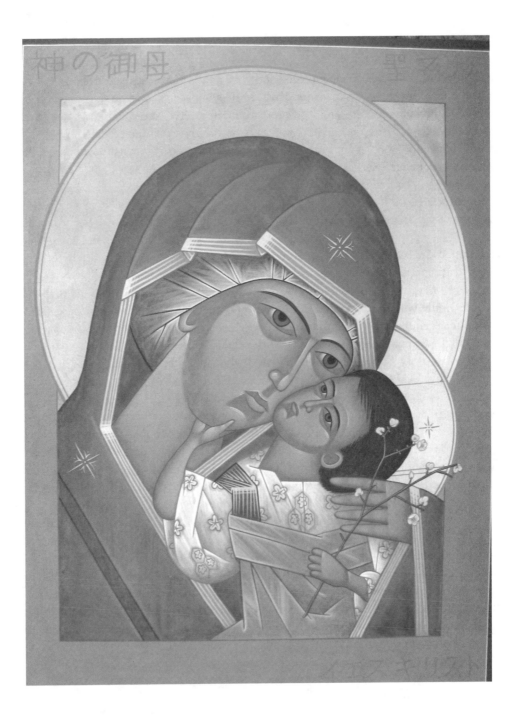

accentuating the bone structure of the facial features. Combined with distinctive garb, these subtle details made for some acceptable representations. In another instance, I was asked to paint an icon of the Mother of God with the Child Jesus for a monastery in Japan. Through the use of a simple change in the shape of the eyes, I was able to create a more Asian look. In both situations, hair color helped me to paint the look I was going for. Both Asians and Native Americans have hair that ranges in color from black to a very dark brown. Sometimes the color is so dark that the highlights take on a bluish tint. It's striking and beautiful to see in person and can be exciting to paint, but do not use black for your base color. No other color will sap an icon of life as much as black. Try using a combination of brown and blue that will allow you to evoke black without any of the deadness that true black brings into a piece.

HAIR AND BEARDS

You've probably noticed that people in icons have all kinds of hair: curly, straight, long, short—or none at all. They have brown, black, and gray hair. Our fathers in the faith sport cropped beards, curly and bushy ones. Some even seem to have beards that cover their whole body! Compare icons of Saint John the Forerunner (the Baptist) with Saints Basil the Great and Nicholas. Each of these saints has a different type of hair in color, shape, and length. While they all have beards, even these are quite varied. On some of the wilder monastic saints, beards and moustaches are so full that you cannot see their mouths. Icons reflect the vast diversity we see with people in general. Although I have not seen any icons of people with blond hair, I'm certain this is something we'll see at some point in the future. God doesn't seem to have a hair color requirement on the sanctity checklist.

Take a look at the hair styles and types of beards and moustaches that you might find on an icon by leafing through any catalog of icon prints. There are only two types of hair color: gray and everything else (which usually means some kind of brown).

- Gray hair: Use the sankir or skin color as the base color. Sometimes I add shadow around the edges of the head and then highlight using whiter and whiter shades of sankir.

- Everything else: Apply the base color (usually a brown) in washes over the sankir and then shadow around the edges if you want. After that, begin to highlight unless the icon is too small to incorporate highlights. The color for these highlights will depend on whether black or brown hair is being painted. On black hair, you might experiment with a bluish color and then lighten it, while on brown hair you can add yellow to make a straw color. If this becomes too dramatic, calm it down with a wash of reddish brown or burnt sienna.

Halos

Halos, aureoles, or any form of light emanating from the earthly body of a deeply spiritual being were not invented by Christians. Throughout history, many religious traditions have used this visual indicator to convey great spiritual import and significance. Humans have always connected the image of light with spiritual gifts and insight, so it's not a huge leap to realize that our images of deeply spiritual people would be rendered with light emanating from their bodies. For example, images of the Buddha commonly employed this device centuries before Christians were painting images of Jesus and his followers.

There are a number of universally accepted ways we visually communicate meaning or proclaim our belief about unseen realities. Halos are widely understood and accepted as a spiritual statement about the special people in our midst.

Single Halo

The simplest form of a halo is the single, circular line around the head of an individual. This line begins where the neck meets the shoulder on one side and goes around the entire head to the other side. In the Byzantine tradition this line is usually a shade of red and rendered delicately so the halo doesn't appear to make the figure top-heavy. The halo's interior may be left the same color as the background, a lighter version of the background color, light yellow, or covered with gold leaf. (I've even seen halos painted red!) I often use this simplest form of the halo for persons who have yet to be canonized or glorified by the institutional church.

Double Halo

A double halo is merely the simple halo with a narrower or finer halo line placed inside the first, heavier halo line. It shares the same center point with the original circle but is slightly smaller in radius. Adding this second, more delicate circle gives the halo a more refined, finished look and adds a bit of depth to an otherwise flat area. Russian iconographers also tend to place an additional white circle outside of the primary circle. I like to do this especially when the line circling the halo might be of the same value as the background and thus may seem to disappear. Using the white line pops the halo forward visually.

Christ's Halo

Jesus the Christ always has a cross placed within his halo, although only two or three arms of the cross are visible, depending on the inclination of the head as well as the other figures or objects in the icon. The arms of the cross may be painted a contrasting color and decorated with small crosses, jewels, or the Greek letters ωον, referring to God's revelation of the name of God to Moses on Mount Sinai:

"I am who I am" or, in Greek, "The Being." Some contemporary iconographers simply use the English "I AM." Early Italian Byzantine painters preferred the jeweled cross instead of any inscription. Any of these options is acceptable.

The only time Christ is not depicted with a cross in his halo is when he is shown as the angel called "Holy Silence." This image, along with images of Holy Wisdom (Saint Sophia) and the images of God the Father called the Lord Sabbaoth or the Ancient of Days, usually has halos with two squares or diamonds superimposed on them. One square is red and the other is blue.

Square Halo

Although they're quite rare, when they appear, square halos are a visual way of indicating that a living person is exceptionally holy or venerable. Mosaics from both Ravenna and Constantinople show hierarchs and bishops, living at the time the mosaics were created, with square halos. Having once painted an icon of Mother Teresa that she actually saw during her lifetime, I do not recommend using a square halo. From what I hear, she wasn't too happy about it. I was young and full of enthusiasm, too naive to understand that real saints don't want to be made into icons or tamed down by popular memory before their time.

What about icons of people who have been acknowledged as "blessed," but who are not yet official saints of the church? In these instances, I simply give them a halo and leave "saint" out of the inscription. You or another iconographer can add that title at a later time. A word of advice: Plan the lettering so that the addition of that title later will not throw the composition off.

17

Two Halos Touching

Images of the "Virgin and Child" or the "Entombment of Christ" offer an opportunity to paint icons where two halos touch and overlap. In almost every instance, the Christ figure appears more forward in the image, which, in practical terms, puts Jesus' halo on top of Mary's to appear closer to us in the picture. For this reason, I always complete the line work on Jesus' halo first to avoid accidentally creating a situation that requires repair work because I've miscalculated where a line should begin or end. (Naturally I would do all the base painting or gold work at the same time, but the line work follows this progression.)

A variation that's rather new, at least to me, is when two saints stand so closely that their halos overlap. In the last few years, I've received commissions to paint icons of the "Visitation" and the "Holy Family." Doing a bit of research, I found that there are more than a few examples where the circles that define the halo's edge simply terminate at the spot where they intersect rather than having one continue down to the shoulder of the foremost figure. It's a visually interesting way to do two overlapping halos. The only challenge is being precise about where the two circles meet. The slightest overshot can ruin the look.

HEADGEAR

Although most men portrayed in icons are bareheaded, there are still a huge variety of hats and headgear worn by the male figures, and almost all women wear some kind of head covering in icons. These include:

Veils

Veils are common in most images of women and take a variety of forms, colors, and ornamentation. In early Byzantine times, a veil draped over a turbanlike cap (aka, "shower cap") that completely hides the hair became the standard way of depicting adult women. On adolescent girls, the veil usually appears without the shower cap, and their hair is depicted tumbling from beneath the veil. Rarely do any icons show a woman without some kind of a head covering. I can't help but acknowledge cultural and religious restrictions that still prohibit Middle Eastern women from allowing anyone other than their husbands and immediate family to see their hair. A study of Byzantine style helps makes sense of present-day realities.

Headbands

Angels wear headbands that are sometimes jeweled to gather tightly curled hair around the face. The ends of these headbands seem to flutter behind the head in some really marvelous ways. One iconographer sees these as "antennae" for communication with God. Interesting theory, but I'm sure lots of other folks would have a problem with that.

Crowns

Crowns are worn by royalty as well as by the Mother of God in wonder-working images (ones credited with healing, transforming desperate situations, or changing hearts). In most images of royalty, the crowns are of a rather wide variety, and doing some historical research would be appropriate when designing an icon of a specific person. There are many forms of royal headgear throughout the ages, from the Byzantine through the medieval to the Baroque and modern, which, although they share many common characteristics, also differ vastly.

Mitres

Byzantine bishops have worn a crownlike mitre since the fall of the Eastern Empire in the fifteenth century, when they began to wear some of the royal vesture. In the areas under Roman influence, bishops began wearing caplike mitres during the ninth century. (Note: It's inaccurate to portray bishops such as Nicholas of Myra, Patrick of Ireland, Ambrose of Milan, and Augustine of Hippo wearing a mitre because this headgear was not in use at the time.) These evolved over time, taking on a wide vari-

ety of shapes and ornamentation. Mitres of the Middle Ages tended to be rather small, while those of later centuries became grotesquely tall and have vacillated between the extremes in the last three hundred years.

OTHER HEADGEAR

Look carefully at the different hats worn by people in icons and you'll quickly realize there are some very interesting types of headgear represented. You'll see veils, turbans, caps, crowns, monastic hoods, along with a variety of other hats that don't seem to have names. Some of these have meaning; others don't. You'll need to know when the type of headgear is supposed to say something about the person wearing it. A peasant, for example, would never wear a crown; a king would not wear a monk's cowl. Unfortunately, I've seen icons in which the wrong saints were donning the wrong articles of clothing, including hats. When this happens, the clothing can become a distraction and that can interfere with the prayer of those who come before the icon to pray.

Religious Habits

Head coverings for nuns and religious sisters, often rendered in what I consider a rather sloppy manner, especially in icons of Western saints, are probably the result of poor research. There are subtle differences in habits and veils within the various orders of religious women that should be taken into account whenever possible. Unlike in the East where there are no rigidly standardized habits, uniformity does exist in the West, especially within specific religious orders, and should be accurately portrayed whenever possible. Maybe it's just me, but it seems important. I learned a valuable lesson about this years ago when I painted an icon of Saint Martin de Porres for a parish outside of Pittsburgh. Although it was a beautiful image, I got Martin's habit wrong. The kind parishioners told me that it really didn't make too much difference but it has troubled me ever since. So, if I may share from my own mistakes, do your homework whenever you paint an image of monks, nuns, and individuals who wear any type of specialized garments. If nothing else, you'll learn something new.

There is a wonderful side to painting religious habits, which tend to be either brown, black, gray, or white: You get to be challenged to find creative ways to render fairly boring colors. With blacks, try using blue; with brown, try using a straw color; on whites, start with a light (pastel) color as your base and work up to white; and for gray please keep in mind that there are other ways to make gray besides mixing black and white! You could find yourself on an educational adventure into color theory, so don't be immediately put off by what looks like a dull task.

— CHAPTER THREE —
Painting Highlights

Many iconographers soon discover that learning how to model clothing through highlights is perhaps the most challenging aspect of this art. For a long time, my attempts to communicate the intricate pattern of folds of fabric draped over human musculature were haphazard and unskilled. Not knowing what else to do, I did it badly until I learned to do it less badly, and sometimes, even to do it well. My only and best suggestion is that you should study other icons. Notice how highlights are used to communicate that there's a leg underneath a robe. Notice how one leg is usually forward and thus highlighted, while the other recedes into shadow. Arms and shoulders are also brought forth in this manner. Eventually—usually after a long period of frustration—something will suddenly click and you'll realize there's no formula for getting it right—highlighting is far more intuitive than that. Having looked at the icons I have done over the years as well as those done by my students, it's clear that this is the area that requires a great deal of practice and the willingness to do it wrong (that is, less skillfully) until you do it right.

SHADOW

One of the many rules iconographers repeat like a mantra is that there are no shadows in icons. Now, let's consider all the exceptions to that rule that abound in books, churches, and museums. Perhaps this would be a good time to take a break, sip a cup of tea, and leaf through photos of icons from any period, geographic location, or school. I'll bet you see lots of those shadows that aren't supposed to be there. Shadows appear on the sides of mountains, buildings, furniture, and even in the folds of garments. This is probably rooted in the purely practical fact that adding just a bit of shadow reduces the amount of highlighting required. For frugal ascetics living in the middle of nowhere, where every grain of pigment is precious, it's a no-brainer: A little shadow goes a long way.

As I write this, I'm thinking about the bright red cloaks of the martyr saints. It's so much easier to wash in a bit of shadow around the edges of the body than to paint the whole garment a deeper red and then to bring it back with layer after layer of bright red. This is often done during the initial laying in of the drawing, over which base colors are applied translucently so the underpainted shadow

darkens appropriate parts of background features and deep folds of garments. In every case, shadows are used sparingly, deliberately, and transparently so they do not overwhelm or draw attention to themselves.

Marek Czarnecki speaks about the light of God shining through the saint's bodies, especially where those bodies touch their garments. It's as if you could see the glow of their skin shining through the cloth like in the accounts of the Transfiguration where Jesus' body shone with a dazzling light so that his clothes became whiter than human eyes could withstand. There is a clairity to the highlighting of garments in well-done icons if you approach them with this understanding in mind: the form is communicated through the garments by the light that radiates out of the body of the figure portrayed. My own way of speaking about this is less elegant. I say that whatever sticks out gets light and the parts that stick out the most get even more light.

You will notice that this section is very short. There is no way to easily explain how to highlight skin areas, the folds of garments, or even landscape and architectural features. It's not as simple as a formula that if followed would guarantee a successful outcome every time. The text for this section is found in the illustrations scattered throughout this book, especially the black and white images. For some reason, highlights "read" better in black and white. Please *study* these examples and paint what you see until your skill grows and develops.

— CHAPTER FOUR —
Painting Buildings and Landscapes

Scenes represented in icons always take place out of doors, as if on a stage with architectural and landscape elements simply providing a backdrop for the figures. Except for images of the holy and life-giving cross, rarely is an inanimate object the focus of or purpose for creating an icon. This relic of the crucifixion, which is the central focus in the icon of the Triumph of the Holy Cross, usually has throngs of believers gathered to venerate it. In general, though, icons are about God, God's reign, and those whom God has transformed—and that means people. Other things of creation are simply props that human actors use in the divine drama of salvation history. At the same time, there are lots of interesting architectural features gracing the backgrounds of many festal icons to contextualize the scene: churches, walled cities and monastic enclosures, palaces, desolate mountain hideaways, and the mouths of cavernous retreats all become part of the visual narrative.

If the scene is supposed to be happening indoors, that fact is simply flagged by adding a red cloth that is draped over the buildings in the background of the image. This can be done in a variety of creative ways and the cloth itself can be decorated with stripes or embroidered designs to make it more interesting. A word of caution: Don't get so carried away with the background elements that the saint gets lost. Remember, you're painting a backdrop—Landscape painting is an entirely different discipline.

GROUNDING ELEMENTS

The grounding elements (aka, the floors) in Byzantine iconography are usually very simple and not at all fussy. For the most part, they're a way to give the figure something to stand on so they don't look like they're lost in space. You could, for example, add something that looks like a molding strip of a color dividing the floor from the background, adding a bit of complexity to the image without being too fussy or complicated. During the fourteenth and fifteenth centuries, the Novgorodian iconographers enhanced their icons even further by peppering the surface of the ground with small symbols. So far as I've been able to determine, these symbols do not have any meaning; they're simply decorative and certainly do break up the flatness of the image. Occasionally one of the archangels is stand-

ing on a cloud to offer some "grounding." Sometimes the surface your saints stand on will be part of a rocky landscape, in which case the same treatment given to mountains is given to the landscape under their feet. I admit this isn't the most interesting part of iconography, but it's an essential consideration when you plan your colors, so take time to think through how all the elements in your icon will work together to create the look and feel you intended to create.

As a technical matter, use a color that will harmonize the elements. If you're stuck for a good color to use, try a gray-green or a tan/brown. Avoid bright red (for purely aesthetic reasons), or any color whose value is too similar to the feet, shoes, or garments of the saint who will stand on this ground of color. Having made this mistake myself (several times), the problem is that one part of the icon seems to disappear into the other, especially from a distance. As I said before, step back and check your work.

SACRED GEOMETRY AND ICON DESIGN

26

Sometimes we think that we, twenty-first-century Westerners, know more than folks who came before us. That isn't necessarily true, at least not in every case. Our ancestors figured out all sorts of things we depend on in our daily lives, and they did it without the use of computers or sophisticated instruments. They discovered the mathematical principles that we use every day for a variety of purposes, and without their contribution to human knowledge, we wouldn't be able to enjoy the quality of life we have today. Perhaps most wonderful of all is the relationships they saw between seemingly unrelated disciplines.

The Greeks believed in a direct connection between art, mathematics, and theology. For them, all these disciplines emanated from the same source and pointed us back to that source: God. Take a building like the Pantheon in Athens, for example. The Greeks didn't simply throw together a bunch of marble to make a nice building; they did the math, worked with the aesthetics, sought to communicate the perfection that finds its source in the divine and to invite people to an experience of the Infinite through finite things. Icons are meant to do the same: They assist those who pray to encounter God through visual contact with images of perfection. And yet, neither classical Greek architecture nor icons are intended to make you aware of the principles involved in creating or designing them. This piece of the planning is done so skillfully that it's practically invisible. By not calling attention to itself, a good icon propels the viewer into a deeper or higher experience of God. (For instructions about mapping physical proportions, see Appendix B: Constructing Drawings).

BUILDINGS

In traditional Byzantine iconography, buildings are always rendered in "reverse perspective," as are furniture and even people's faces. This means the vanishing point shifts from somewhere out on the horizon line (as in what we call "natural perspective") to the viewer. When it comes to reverse perspective, *we* are the vanishing point. So in an icon with buildings in the background, we see the sides, front, and top of the buildings simultaneously. It's very odd, but think of it as a God's-eye view.

MINIATURE BUILDINGS

Quite early in the history of Byzantine iconography, often in the mosaics of Byzantium and other churches in the Mediterranean area, patrons and donors were included standing among the images of the angels and saints. They were commonly shown holding models of the churches, monasteries, or cities they played some part in naming or creating. In many images these citizens are portrayed standing next to Christ or the Mother of God and bowing in a gesture of supplication, humbly offering their gifts. The little model buildings they hold are often portrayed in either a reverse or distorted perspective.

More contemporary icons frequently show the patron saint of a church or monastery that bears his or her name and seek his or her protection—an effective way to connect a specific faith community with its patron saint.

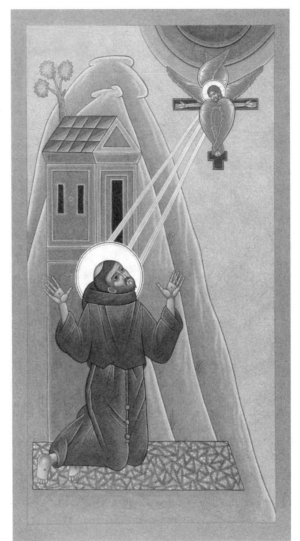

Mountains

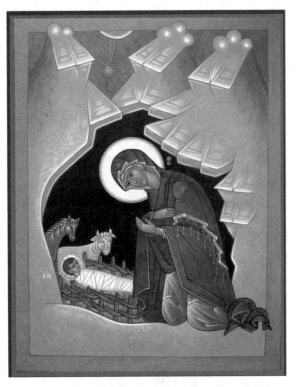

I enjoy painting mountains. They're really fun and not at all like the rolling hills or "purple mountain's majesty" we drew in elementary school. Instead, they're more like the craggy, alien rock formations on the set of *Star Trek* or, perhaps more accurately, like the landscape around Cappadocia in Turkey. In icons, mountains signify a deserted place and frequently resemble a stone "stairway to heaven," which is not a bad symbolic reference to the desert solitude where many Holy Ones have taken refuge.

The look of mountains and rocks has remained surprisingly consistent over the centuries, even though most iconographers have never been to Turkey. There's a certain science to creating the wonderfully impressionistic rock formations that signify mountains that is closely akin to the engineering that goes into creating a great piece of architecture, except in this case we use inverse perspective to show several sides of the mountain simultaneously. Like stairways, they have a side, a front, and a top. The sides are usually shadowed a bit and the highlighting is concentrated on the top of each of the "steps," although sometimes the fronts are also highlighted a bit. Colors range from earthy oranges to lavenders, greens, and blues. The only rule here with regard to color is that there is no rule. But be careful not to overwhelm the saint or scene taking place in front of this glorious backdrop. Have fun with this part of the composition. If it seems too stark, a small amount of vegetation may be added after the rocks are finished.

Caves

Caves and crevices are common, especially in icons that include mountainous terrain. Elijah hides out in a cave. Saint George's dragon emerges from a cave. The Eastern Nativity icon presents the scene of Jesus' birth in front of a cave rather than in a stable. The Anastasis (Christ's descent among the dead) icon shows Christ standing on the Gates of Hell that span the entrance to a cave. Caves are everywhere

in the imagery of icons. Rather than simply referring to hell or evil places as "down there," caves can symbolically speak of the ignorance from which we emerge into the light of knowing and faith, or they can be womblike places where God works on us to make us ready for some mission of service to the world. In iconography, caves can be references to the tomb or death, or even the fact that God is the only real hiding place where we can find safety.

As a practical matter, caves are simply rendered as a dark place. Black may be your first choice but perhaps not the best one. Mixing a dark color of blue and brown will provide a richer and more interesting alternative; throw the tube of black paint away. If you must use black, add a bit of another color to lessen the deadness that is one of the problems of pure black. This, by the way, is an artistic piece of advice rather than an icon painting rule.

Aureoles, Mandorlas, Glimpses of Heaven

Often you will notice that in the top corner of an icon there appears a series of blue concentric circles, sometimes with a hand poking out of it or a needlelike projection pointing down to something in the image. At other times you'll see a figure standing in front of these blue concentric circles or an elliptical shape of the same colors. This is an aureole which is simply a visual code to let you know that you are getting a peek into heaven even though the scene is supposed to be taking place in this world. It appears in images of the Harrowing of Hell (Anastasis) or the Dormition (Falling Asleep) of the Theotokos, or even in the images of Christ sitting in glory on a throne surrounded by throngs of dancing angels. Sometimes in our faith and in our icons, heaven and earth collide and intersect in ways that blesses and transforms our reality into a bit of heaven.

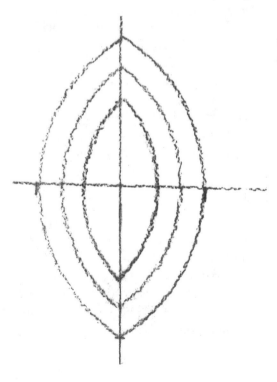

Water

Water is another element I enjoy painting. A survey of any reference book on icons will show that water is always painted in an impressionistic manner that

seems to conjure up the feeling of movement. Some modern painters in the Russian style have done wonderfully playful work with water in their icons. The real danger here is to do too much. A few simple lines over a blue base, rather than lots of fussy little details, will reveal waves and undulations.

The whole process becomes a bit trickier if you have a figure in the water, such as Christ at his baptism in the Jordan River. In cases such as these, consider painting the figure first and then adding highlighting on the water afterward so that it actually looks like transparent water flowing around his legs. Think through the way you'll need to proceed before beginning to do this. First, lay in the base colors of the water and of Christ's legs, then highlight the legs and outline them. After you finish, highlight the waters and reinstate the necessary lines on top of the work you did on Christ's legs or whatever might have been in the water in the icon you are painting.

VEGETATION

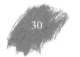

Trees, shrubs, plants, and flowers appear in iconography as background elements serving to enhance the importance of the scene and the holy ones depicted in the icon. While vegetation is usually simply rendered, it's also very interesting and expressive. I've seen trees that looked like something out of a Doctor Seuss book (for those of you who did not grow up in the mid-twentieth century, it might be worthwhile to take a look at the fanciful trees he created for his children's books) and grasses that appeared to be no more than a few simple brush strokes. Vegetation is quite impressionistic and easy to create.

One of my favorite techniques for creating trees is to paint a dark base on the trunk and then add yellow hatch lines to create volume. There is no need for huge efforts to create realistic portrayals of plant life but rather a whimsical impression that softens the background of the scene that is presented. Study prints of the master iconographers to see how they addressed vegetation in their icons. Let their work inspire some playfulness in yours.

ANIMALS

Because many iconographers in past centuries had never encountered some of the creatures they painted, they created the most interesting elephants, camels, and lions you'll ever see. Look at the faces of sheep, cattle, donkeys, and horses on old icons; they are very odd and almost human. Again, since animals are never the point of an icon, there's no great emphasis on the accuracy of the rendering. Sometimes horses are red and cattle are blue, but they all serve as props to present a biblical scene or a holy person.

Note that the animals in icons are never cute; they're merely functional. Animals add to the narrative of the icon but do not inspire affection nor do they draw attention to themselves. Although all creation is being redeemed and restored, the focus of any icon is on God and the saintly figure transfigured by God's grace. Everything has to be kept in a sober balance so the right spiritual message, rather than a scientifically precise rendering, is conveyed.

— CHAPTER FIVE —
Painting Figures

Although icons are about God, they focus on the human figure in which God is incarnated or made present in the world. Figures bear the weight of communicating God's presence. The way people stand, whether their legs communicate vitality and movement or a calm stillness, what they do with their hands and arms, the tilt of the head, and whether they hold something or not—each of these considerations helps to communicate something about the saint or angel and about their role in salvation history. Monks are not usually shown running or in agitated motion; instead their body language speaks to us of stillness and silence (unless they are climbing the Ladder of Ascent made famous by Saint John Climacus). In the same way, angels are always shown in a freeze-frame glimpse of their constant activity, often communicated by the fluttering of their headbands, if by nothing else. As messengers, they're always on the go in their untiring mission to deliver the word of God.

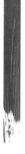

The pose or position of figures in icons painted by knowledgeable iconographers is always well planned. Although it may seem as if little thought or effort went into how the figure is presented, that's an illusion. In actuality, the fact that the position of the figure seems uncalculated is an indication of masterful planning. Used well, iconographic principles do not draw any attention to themselves and the icon allows you to pass through it to the place of silent, prayerful encounter rather than becoming fixated on the image itself. A masterpiece is best judged by how little attention it demands of the viewer.

Spend some time looking closely at the poses of the figures in an icon, especially the secondary figures in a feast day or narrative icon. How do their pose and gesture underline the action of the primary figure? Similarly, the graceful gestures of the hands in icons can speak volumes. Some gestures speak of prayerful silence and submission, some speak of power and strength, some point to something unseen or invoke a sense of invitation to come closer, and some speak of sadness and grief. Subtle changes in the gestures made by the persons in icons can change the whole mood and message of the image. One wonderfully graphic example can be found in the icon of the Raising of Lazarus, in

which a member of the crowd of onlookers holds his nose, dreading the "stink" referred to in the story (John 11:39). Spending time with other icons will reveal equally interesting poses and gestures that underscore the visual narrative's meaning.

The stance of the figure, the placement of the arms, the tilt of the head, the slope of the mountains, and the curve of a scroll are just a few things that create a sense of peaceful unity and flow in the icon. They're designed intentionally as a result of knowing some basic geometric concepts passed down to us by the ancient Greeks, who believed that mathematic principles, artistic beauty, and theological/philosophical knowledge were all of divine origin. For the Greeks, these disciplines formed a fundamental unity rather than being opposing forces. Sacred geometry has been around for a long time and it has lasted because it works. Father Egon Sendler, SJ, has spent the greater part of his life studying iconography and sacred geometry as well as teaching and writing to help others grasp the relationships between these two disciplines. His book, *The Icon: Image of the Invisible*, is an excellent resource about the principles of sacred geometry that are fundamental to iconography.

As a practical exercise, make a copy of an icon done by one of the masters of the fourteenth or fifteenth centuries. Lay a piece of tracing paper over the photocopied image and divide it in half both vertically and horizontally. Next, place lines from corner to corner diagonally. Subdivide the image using the horizontal and vertical lines and then draw diagonals within those boxes. Notice how many of the lines of the icon fall on the horizontal, vertical, and diagonal lines. My bet would be that a significant number of correlations will emerge. Add to these the possibility of arcs that introduce curved lines to the angular ones already mentioned. It's all there in a well-designed icon. Even though your brain doesn't see the lines themselves, it sees the relationships. Our minds are always looking for patterns to make sense of things—that's how we learn and relate to the world. As iconographers, we need to learn to use this natural intellectual tendency to lead people to God through the conscious and skillful methods we use to create the images we paint. (Please see Appendix B.)

A few years ago, I was in the studio of Vladislav Andreyev and came across an icon of the Holy Silence, an image of Christ before the Incarnation in which Christ's arms were crossed over his/her heart. It was a beautifully balanced and grace-filled gesture that left me feeling quite calm and filled with awe at the simplicity of the way in which the iconographer had designed the hands to invite us to experience a bit of holy silence for ourselves. It reminded me of an icon of Christ the Bridegroom by Domenikos Theotokopoulos, who we know as the painter El Greco. I had seen it in the treasury of the monastery on the Greek island of Patmos. That icon had an equally beautiful gesture of humil-

ity and calm in the midst of great suffering. Such artistic genius begins with a good drawing based on a profound understanding of the ancient principles. As I've mentioned before, the initial sketch is extremely important and this fact cannot be circumvented with shortcuts if you really want to do your job as an iconographer well. Take the time to plan before you even put pencil to paper. It will make all the difference in the world.

MUSCLES

Icons of the Baptism of Christ or the Crucifixion or even Saint Mary of Egypt offer opportunities to paint the musculature. Unlike the images of idealized humanity painted by Michelangelo on the ceiling of the Sistine Chapel, our work will be far less voluptuous and "beefy" because of the ascetic and other-worldly stylization of our Byzantine prototypes. Michelangelo's work celebrated human physicality as an expression of the divine. As iconographers, we have to keep a balance between human and divine but not lose the spiritual in the mix.

In iconography, the human body and its muscles are merely suggested and not dwelt upon. They give the impression of mass and volume without becoming obsessed with anatomical precision. If a "six-pack" (the muscles of the abdomen) turns into an "eight-pack" in an icon, no one really seems to notice. Above all, the amount of modeling done on the muscles is directly related to how big or small the icon. Smaller icons demand less fussy detail and simple touches of light. Big icons can carry more extensive development of the musculature. In every case, the muscles are not the point; they only help us to see the human form as a vehicle for the spirit.

35

LEGS

No doubt about it, the people in icons tend to have extremely long legs, especially in some of the Russian icons from the fifteenth and sixteenth centuries. The positioning of the legs is subtle and can add to or take away from the overall graceful elegance of the image. Rarely will a good iconographer make the saint just stand there with both feet planted firmly on the ground, side-by-side, like some awkward adolescent posing for a class picture. Instead, the legs are shifted with the "weight" being placed on one leg while the other is bent at the knee. (This would be a great time to pull out one of your icon books to see what I'm talking about.) It gives a sense of stability to the figure without being slavishly symmetrical.

Our icon-painting ancestors did not invent this insightful use of subtle positioning. The ancient Greeks discovered it nearly three thousand years ago. Older examples of Kouros sculptures show

human figures with their feet firmly planted on the ground and their arms hanging at their sides. When it dawned on the Greeks to introduce variety into the mix, artists added all sorts of movement and dynamism to their work. Iconographers use the wisdom and insights of the Greeks to keep their icons from being too stiff or boring. Even a slight shift of the weight, translated into a change in the positioning of the leg, can make a huge aesthetic difference, adding some variety and interest to the images we create. Learning from the past is the best way to avoid having to make the same old mistakes over and over again, allowing us to be more skillful in our work.

How much highlighting is done on the legs depends on how much detail information is intended—and that's based on the size of the panel, the distance from which it will be viewed, and so on. Minimally, you'll want to refer to the main muscle areas of the thigh and calf. Don't forget the kneecap. Every joint is usually rendered as a dark area where the base color is untouched by highlight color. The main question is whether it is believable—maybe not to a medical examiner but to an average viewer.

HANDS

Hands are expressive, and the hands of figures in icons can say a great deal, even in the silence. At times they indicate meekness, supplication, blessing, prayerfulness, and tenderness. Or they can draw our attention to another part of the icon (a person or an event). Take a few moments to study hand gestures in some icons. They can be amazingly graceful, yet filled with strength and power. Now study your own hands. Notice the way that each finger is made up of three bones. Even the thumb is constructed this way, although the bone closest to the hand is not visible. Notice the fleshy areas on the palm at the base of the thumb and the little finger or the knuckles along the back of the palm. Look at the way your fingernails crown each finger. Even though we look at our hands every day, we can often fail to really see them. The hands rendered in icons are the same as our hands, only idealized to create a sense of placid harmony. Just a small note here: I often omit the fingernails on the icons I paint. Either the image is too small to fit them in or it's very large and meant to be viewed from a considerable distance. In either case, I've seen nails rendered awkwardly so often that I don't want to risk that mistake. Perhaps I simply need more practice.

It is my understanding that in the Byzantine court, whenever something was handed to or received from the hand of the emperor, court officials veiled their hands as a sign of respect. This practice, like many other details of courtly life, was carried over into the liturgy of the church. It is very common to see these veiled hands represented in iconography. Bishops often have their hands draped with a cloth or use their cloak to cover their hands while holding the book of the Gospels. And it is not uncommon to see people holding icons with veiled hands. In every case, a statement is being made about the scared nature of what is being carried or caressed by the person represented. Sometimes even Christ has his hand covered as he clutches the book containing the seven seals.

Like hand gestures (mudras) in the images of the Buddha, the hands of those whose images are conveyed to us in Byzantine iconography speak volumes. Consider the hand gestures of Christ, the apostles, those of priests and bishops as they bless. It's a sort of sign language for the name of Jesus Christ. In fact, they bless us with the "name that is above all other names" spoken of by Saint Paul in his Letter to the Philippians (Phil 2:9). Icons of Saint John the Theologian (the evangelist) show him pressing a finger to his lips to indicate silence from which he utters: "In the beginning was the Word . . ." (John 1:1) Hands can speak volumes, so use that fact to your advantage and plan well.

FEET

Feet also have to be believable if not anatomically accurate. This means you suggest the ankle bone, the toes, the arch, and all the parts of the foot without too much fussiness. It's just a foot, but it has to read as a foot without distracting someone trying to pray while looking at some flipperlike appendage sticking out of the leg of someone's trousers. Believe me, I've painted some interestingly poor substitutes for feet plenty of times, but I have gotten better over time. Study good icons, practice, and keep moving forward.

WINGS

In the English language, a flock of larks is called an "exultation." For some reason, that always reminds me of painting wings on icons. If any part of iconography can be described as joyful and fun, I think it would be painting wings. A quick look through any icon book will make it apparent that wings are some of the most interesting things in icons and perhaps one of the places where iconographers have allowed themselves a bit of playfulness throughout the centuries. The colors, the movement, the play of lights and shadow are wonderfully creative and celebratory, especially in larger icons, in which layer upon layer of feathers combine to create wings that are both believable and artistically innovative. This is one element in which Italian painters did some of their boldest innovations as they moved away from their Byzantine counterparts after the eleventh century. Some frescos by Fra Angelico present angels whose wings contain the colors of the rainbow, and later Eastern examples seem to echo this love of color in the wings of their angels as well.

As a student of iconography, notice how skillful iconographers highlighted layers of feathers in their angels' wings. Unlike in naturalistic Western art, the light does not fall on the tips of the feathers but on the areas beneath them. This is one place where it is easy to spot the work of a beginner who may have failed to recognize the uniquely Byzantine way of doing highlighting. Check out what the masters did and proceed.

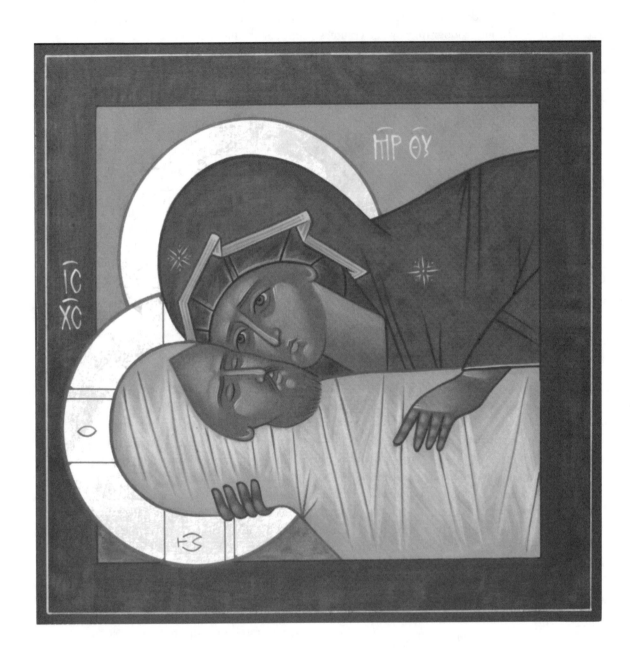

— CHAPTER SIX —
Painting Garments and Accessories

Painting the folds of garments that drape the human figure in icons is not easy. Perhaps more than any other element in iconography, I found highlighting clothing to be the most challenging part of learning this art. To complicate the matter further, having other artistic experience will probably make things more difficult. Painting drapery in icons so it looks like there really is a body underneath is quite unlike what needs to be done in other forms of art. Beginning with the base colors, lighter colors are layered in the areas where body parts or folds are to be accented and lifted from the shadows. It's like sculpting with light instead of clay to create a bas-relief image of color. Good highlighting on garments is easily recognized, but so is less skillful work. Study and practice are essential to becoming better iconographers, especially in this specific area. Add to that the necessity of knowing about particular types of garments worn by people from different periods of time, in different cultures, and from different parts of society: clergy, royalty, peasant, soldier, monastics, and so on. Garments are a very important element in iconography because they say a great deal about the person wearing them. Lots of anachronistic renderings of the saints appear all the time and although it probably goes unnoticed by most people, we should try to be as thorough as we can in order to minimize the distraction of errors for those whose only desire is to pray.

ROMAN/BYZANTINE CLOTHING

Many items of ecclesiastical (that is, church) vesture in both the East and West come from garments worn in the Roman and the Byzantine empire around the time of Constantine. Some of these items of clothing were ceremonial, but many more of them were quite ordinary and common articles with practical origins. As time passed and styles changed, the church held onto the earlier fashions, transforming them into ritual clothing, often assigning them esoteric theological meaning. As with most things, the roots of church vesture are often rather common and pragmatic, which only later were layered with symbolic meaning. Get a good book about vesture and study it. It's important to understand what the articles of clothing were, how they were cut and arranged on the human body, and their symbolic meaning to competently render them in an icon.

CHITON AND HIMATION OR ISPOD AND RIZA

The ordinary clothing of the apostles, saints, and martyrs of the early church, both male and female, is known by several names that simply mean either the inner or outer garment. In old icon painting manuals, these are noted, designating the appropriate colors for the specific saint. Basically, what we find is an inner garment that looks like a tunic (Chiton or Ispod) with long sleeves over which a cloak-like outer garment (Himation or Riza) is wrapped in a variety of ways. Rarely are figures rendered wearing only the inner garment. That's actually a good thing because the beautiful drapery happens as a result of the ways the outer garment is wrapped around the body over the inner garment.

CLAVIUM

On most icons of Christ, the apostles, and some angels, there appears a visual reference to a stripe that runs down either side of the inner garment from the shoulders to the ankles. It is often rendered to suggest gold embroidery and is, in fact, created using gold assist or small hatch lines of gold leaf. These "stripes" are the clavium or clavi and signify significant social rank.

If you take a look at Roman frescos depicting scenes of daily life, you'll see that certain figures (almost always men) wear white tunics accented with purple stripes. In that culture, only the emperor wore the royal color purple. Senators and others around the emperor shared his power and this was signified by their right to wear a bit of royal purple on their robes. When the early iconographers began representing significant leaders of the Christian faith, they used this cultural convention to say something about those they depicted and about their cosmic significance in salvation history. Since the Kingdom of God is far greater than the kingdom of any Caesar, it only seems right to convey the message that Jesus, the angels, and the apostles are at least equal to, if not greater than, these worldly leaders.

Often the clavium or shoulder stripe appears to suggest it's only on one shoulder, but it should be applied on both sides of the inner garment, running from the shoulders down to the bottom of the garment when possible. Since Jesus wears the purple (deep red) garment, it's necessary to apply flashes of gold leaf or light yellow hatchings to indicate the presence of the clavium on his garments. This makes the clavium look like they are some kind of gold embroidery. Over time, this effect seems to have carried over to other places where the shoulder stripe is used. It's one of those details that, once you're aware of it, you'll notice in many icons. Keep your eyes open!

DIACONAL, PRIESTLY, AND EPISCOPAL VESTURE

If you visit the church of San Vitale in the Italian city of Ravenna, you'll see some magnificent mosaics dating from the fifth century. Among them is an image of the Emperor Justinian standing with his bodyguards and members of the clergy. This image gives us a clear illustration of the vesture worn by deacons and bishops at that time. Usually the liturgical sign of the deacon is the stole, worn over the left shoulder, but in this mosaic we see only the dalmatic, a flowing tuniclike garment often bearing stripes like the clavi. This mosaic shows the deacon in a white, full-cut dalmatic with dark (black) shoulder stripes.

Priests and bishops wear the chasuble or penulla, a garment similar to a very large poncho extending to the ankles on all sides. Later, the garment was reduced by cutting away the front in the East and the sides in the West. In earlier times, this overcoat was worn to protect both men and women from the elements. Again, the garment was usually rendered in white in early Byzantine mosaics. The insignia of the bishop was the omiphorion or pallium, a long white scarf worn over the chasuble. It had dark (black) crosses embroidered on it. This garment was greatly reduced in size in the West, although is still used by the pope and the archbishops of the Roman church even in it's diminished state. Eastern bishops still wear a very large version of the omiphorion, which remains the sign of the episcopate in the East. Gradual developments in both the East and the West would add the crozier (staff) and mitre (bishop's hat) to the insignia of the bishop in later centuries.

41

MONASTIC GARMENTS, THE GREAT SCHEMA, AND RELIGIOUS HABITS

In the Western church, we are accustomed to all sorts of religious communities, each with a distinctive habit or style of garment. This was especially evident up to the time of the Roman Catholic's Second Vatican Council, when many communities modified or abandoned the habit. Still, many communities continue to wear some kind of habit. These distinctive garments can vary greatly. Benedictine habits differ from those of the Cistercians; Franciscans and Dominicans wear different garments—even the distinction between choir monks and lay brothers/sisters is conveyed by what they wear. Habits vary in color, cut, and—for women's communities especially—style of veil. There are even subtle variations within each religious order that may only be obvious to the members of those communities.

The church of the East is less specific and simply recognizes the monastic order rather than a multitude of specialized communities founded by charismatic leaders throughout the centuries. In the East, those in the religious life are referred to simply as *monastics*. Their garments are distinguished by earthy, dark colors that represent voluntary poverty and the penitential emphasis of their lives.

Monastic clothing consists of a cassock-like garment over which a vest, a cloak, or a flowing robe of the same dark color (usually black) is worn for worship. There isn't much distinction between the garb of women and men; in fact, women are often shown wearing the same pointed hood that the men wear. The only difference is that women's heads are always covered and the head covering can take several forms depending on geographical area and historical period.

After a long time in a monastery, certain monks and nuns arrive at the highest degree in Eastern monasticism, called the "Great Schema." This is signified by a very specific garment resembling a scapular or apron-like panel that runs down the front and the back of the body. This panel is embroidered with red crosses and portions of the Trisagion prayer ("Holy God, Holy and Mighty, Holy and Immortal One, Have Mercy on Us.") In the Coptic (Egyptian or Ethiopian Christian) tradition, the schema consists of a leather cord with crosses attached to it.

Study the icons in any good reference book and you'll begin to recognize monastic saints from any period or geographic area. Almost every kind of drab color, from black to gray and brown, has been used to render their garments. The good news is that the iconographer can sometimes employ other, more interesting colors to highlight these dull base colors and there's ample room to create—within reason. I've noted that greens and blues can be very effective in communicating black garments, while reds and straw colors work nicely on brown, and grays can be enhanced with almost any well-chosen color.

Having noted all this, especially for iconographers from the West, it's important to return for a moment to the various religious uniforms or habits worn by men and women who live vowed lives in communities founded by the Western churches. It is not uncommon to find dramatic errors, although probably innocent ones, in the icons of many less-experienced iconographers in the attire of nuns, sisters, monks, friars, brothers, and so on. Consider this: The habit of the Carmelites is dramatically different from that of the Franciscans, even though they are both (for the most part) brown. Also, the habit of the Cistercians (a reform group descended from the spiritual children of Saint Benedict) is different from that of the Benedictines. To make matters more complicated, the habit of the Capuchin Franciscans is different from that of the Friars Minor, which is also different from the Conventual Franciscans or that of the Third Order Regular (which are also black and not brown), and none of them is exactly what the poor little saint of Assisi wore. Confused yet? How about this: The Swiss congregation of the Benedictines in the United States have a slightly different habit than that of the American Cassinese (Bavarian). In addition, different ranks within religious communities were marked by different habits for lay brothers and choir monks. And don't forget the interesting veils and sundry headwear worn by women. A quick glance at a photo of Saint Therese of Lisieux, Saint Teresa Benedicta of the Cross (Edith Stein), and renderings of Saint Teresa of Avila reveal that something as simple as the way the veil is folded makes a difference in the look of the habit. All of this should be taken into account when creating icons of the sons and daughters of Benedict and Scholastica, Francis and

Clare, Dominic, Teresa of Calcutta, Brother Roger of Taizé, and all the other holy people who lived out their lives in religious communities within the greater church.

The colors of religious habits has tended to be limited to the more simple, earthy colors of black, brown, gray, and white, but there are lots of exceptions to this which include shades of blue, red, green, and even pink! Like I always say: Make a rule and you'll find at least fifty exceptions within the next week. Thorough research will help you to be as faithful as possible to the image of the saint you're trying to render. Do your homework—it's definitely worth it.

MILITARY GARB

Because the East has many soldier saints and there are times when the Archangel Michael is portrayed in armor, you'll need to know the various ways battle armor is worn, rendered, and decorated. First of all, forget Sir Lancelot and the Arthurian legends that the Pre-Raphaelites used in their romantic recreations of medieval legends. Byzantine armor is simple: a chest covering, skirt, and short sleeves all made of some kind of metal or leather. Legs are not clad in protective gear, nor are the forearms. The rendering is fairly simple too; each piece of the gear is highlighted with simple flecks of light resembling the fine hatching found on anything that's supposed to be made of metal. I usually use an earthy orange base color with light yellow highlights.

There are also any number of military weapons and accessories which will be addressed a bit later

MODERN GARMENTS

You won't often see people in business suits, neckties, jeans, polo shirts, or other contemporary clothing in icons, but it's not entirely unheard of. One reference book on my shelf has a Russian icon of a man in camouflage battle fatigues! Saints wear what they wear. Icons of Saint Xenia of Saint Petersburg show her wearing the garments of a street person of her time, and icons of the Desert Mothers and Fathers show them wearing garments of their time, not to mention their place. Rather than canonizing the clothing of any specific era, the people of God canonize the holy ones who wear the clothing.

No doubt as we move further into the twenty-first century, the saints in our midst will be revealed, and as long as God continues to make some of us saints, iconographers will continue to create icons of them. To do this, we will also have to find ways to render their garments to convey grace, dignity, and beauty. Obviously, the flowing folds of garments of earlier times are more pleasing in many ways, but they're only the wrapping. Whether you like his subject matter or not, Robert Lentz does a wonderful job of rendering contemporary figures in their very contemporary clothing. Take a look at his images

of Martin Luther King or Dorothy Day to see how the Byzantine style can be invoked to paint modern garments. If we work at it, we should be able to make a T-shirt look glorious in the service of God.

PATTERNS ON CLOTHING

Lots of icons present the saints in very simple and unadorned clothing, but there are also many examples of garments that come alive with all sorts of embroidery and patterns. From chasubles covered in a checkerboard pattern of crosses to coats that look like rich brocade or even a simple plaid-like design, putting a pattern on a garment is fun and effective when done well.

The cross pattern I mentioned earlier can be tricky to paint. I usually lay it out on a sheet of grid paper to make sure I get it right. You should know up front that if you get one box wrong, the whole pattern changes. But don't freeze with panic. Unless it's really messed up, it will probably not even be evident. Also, you can easily do some transparent highlighting over the pattern if you wish to flesh it out a bit, but many icons lack any sort of highlights on patterned garments.

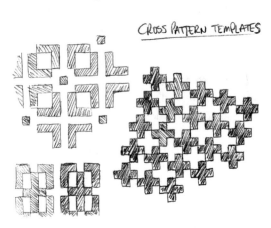

CROSS PATTERN TEMPLATES

Iconographers rarely make any allowance for folds; the pattern is simply laid out as if the whole garment were flat and two-dimensional. The same is true for more elaborate floral designs that look like brocade; lay them on flat and highlight sparingly if at all.

When painting something that looks like a tapestry, I recommend sticking with a monochromatic scheme rather than adding several colors. The point is to add interest, but to do so without drawing attention to the garment to the point that the saint appears as an afterthought. Even the most intricate pattern can, if painted skillfully, be subtle and serve to complement the icon rather than overwhelm it.

SCROLLS AND BOOKS

Any number of books, scrolls, or bannerlike, fluttering objects appear in icons. When Christ appears with an open Gospel book, it is often opened to one of the "I am" statements from John's Gospel ("I

am . . . the bread of life, the good shepherd, the light of the world, the way and the truth and the life, the alpha and omega, the resurrection, and so on—See the Gospel of John) or the invitation to rest ("Come to me, all who labor and are burdened, and I will give you rest" [Matt 11:28].). In these icons, Christ is portrayed as the teacher. At other times, he is presented as the just judge as he holds the closed book of the seven seals from the book of Revelation.

The evangelists are sometimes shown in the act of composing the Scriptures. Bishops usually hold a closed book, although there are many examples in which the book is opened to a specific passage. The great letter writers, such as Paul and Peter, are often portrayed holding scrolls or bundles of scrolls or books. Sometimes short passages from their epistles are presented in the image. The same is often true for prophets and figures from Hebrew Scripture (or the Old Testament). Other saints, especially those known for their writings or even their orations, will be shown holding a scroll on which a small piece of their work is shown to give the viewer a sense of the personality or piety of the saint. At times, these scrolls can be quite fanciful and almost decorative as they seem to flutter in the wind of the Spirit. On some rare icons, in which a scene would not make sense without giving us an idea of what is being said, the words of speakers are represented as a ribbon coming forth from their mouth. This is an effective and somewhat medieval way to get the message across that our modern comic strip artists have adopted and adapted quite well.

CROSSES

Whenever possible, martyrs should hold a cross in their hands. The cross is usually unadorned and never portrayed as a crucifix (that would be very Western). The Western tradition often gives them palm branches or crowns of laurel leaves, but in the East, martyrs always hold a cross.

I've noticed a bit of confusion on this matter in some contemporary icons and find all sorts of examples of saints holding crosses simply because they are Christians—I presume. Naturally, there are at least a few exceptions to every rule in iconography and this is one of them. Saint Helena, the mother of Constantine, is reported to have discovered the relics of the true cross in Jerusalem and so she is often shown supporting a large cross. Saint George was a martyr, but when he's shown slaying the dragon, he sometimes appears without a cross. Instead, he's given a red cloak or the background of the icon is bright red in reference to the blood he shed as a witness to Christ. In other images, his lance will have a cross at the end opposite the point.

On a practical note, I recommend adding elements like crosses after completing work on garments or skin areas so you don't have to "work around" these details. Doing this will spare you a great deal of frustration and maybe even simplify your own life a bit.

MEDICINE BOXES AND SPOONS

In the East there is a category of saints called the "unmercenaries" who were doctors or healers. These men (unfortunately, I've not come across any female unmercenary saints) did their work without material compensation, serving because it was the right thing to do. When portrayed in icons, they hold a medicine box and a spoon. The box is usually red or deep orange with glistening yellow or gold highlight lines. Saint Pantelemion is one of the best-known unmercenary saints.

WEAPONS

Although it may seem strange or inappropriate to include any sort of weapon in images of the Kingdom of God, this does happen rather frequently.

There are many saints who have done battle throughout the centuries. Saints George and Demetrios are two from a category of warrior saints so the implements of war such as shields, spears, swords, sheaths, and the like are quite common. Not only are some of the the holy ones depicted holding weapons, but they are even shown using them against dragons and infidels (please note that this is traditional language, not my own). Even angels can brandish swords or spears, as in the icons of Saint Michael portrayed as a warrior.

Weapons are often added after the main garments have been highlighted and the lines reinstated. But the armor is an integral part of the clothing, so that's done when other garments would have been painted. Simple flashes or lines of light are all that is required to create believable "scales" of armor as well as glistening swords and spears.

One little fun-fact that bears sharing is hidden in some fifteenth century icons of Saint George fighting the dragon. His shield bears the image of a sun disc, which seems rather innocent until learning that the people of Nothern Europe and the Slavs were sun worshippers prior to their conversion to Christianity. The remnants of the old religions found their way into the images of Christianity. That probably doesn't help you understand the presence of weapons in images of faith, but it is interesting. (See the section containing drawings for an example of this.)

46

ORBS

Angels and archangels are often shown holding what look like crystal spheres or orbs inscribed with the name of Christ ("IC XC" or just a simple "X"). The origin of these orbs is not clear, but there is a theory that a very old ivory icon of Saint Michael (525–550 AD in the British Museum, in which

Michael is holding an orb, is painted on a panel that at one time contained two figures. Presumably the missing figure on this icon was an image of the emperor and Michael may have been handing the orb (a sign of power or dominion) to the temporal ruler. Without the image of the emperor to give context to the scene, it could be interpreted that Michael simply holds an orb. Later iconographers may simply have copied this rendering without any knowledge of the meaning of the orb and simply considered it an attribute of the archangel. Valid theory? Maybe not, but it's fun to do this detective work at times. In any event, when orbs are pictured, they're often made to look transparent, even milky. Otherwise they're painted as concentric circles in shades of light blue. The lettering is often done in red. A casual leafing through any icon book will provide lots of examples of this imagery, which is added after nearly all other painting is completed.

REPRESENTING THE PREFIGURING OF INCARNATION OF CHRIST

One rare image is more of a theological statement than anything else. It shows the "synaxis" (gathering) of the angels and archangels around a medallion showing an image of Christ as either the Emmanuel, that is the Holy Child, or the adult Christ. This icon is meant to convey the belief that the angels took God's side when Satan rebelled against God and God's plan to become incarnate in Jesus. This medallion can be rendered in full color or monochromatically in shades of blue.

Folks in icons hold all sorts of things, but even being empty-handed serves a purpose. I remember how, as a monk, I spent a great deal of time looking at the windows and the other artwork in the abbey church between moments of prayer, or when I got bored. One of the windows had an image of Tobiah being led by the Archangel Raphael, with the most wonderfully animated dog at his feet (Tobit 6:1). That pooch gave me many a moment of joy as I sat in my choir stall waiting for prayers to begin. Anyway, the apse of that church had several windows representing the founders of major religious orders: Benedict, Bruno, Dominic, Romuald, and Francis. Each held items that spoke directly to his story or embodied the characteristics of the communities they founded—except for Francis. His hands were empty. I was very impressed by this and at the way it underlines that Francis's greatest gift to the church was not his love of nature and animals but his poverty. In the context of the others standing around him, Francis's empty hands are striking.

INSCRIPTION PLACEMENT

Inscriptions are an important but not the most important part of iconography. Still, that's no excuse to cut corners, skip them completely, or do the planning and calligraphy poorly. (I've done that and it never works well). Iconographers have, in certain centuries, rendered the inscriptions so beautifully that they are, in themselves, some amazingly lovely art. Along with that, they have placed the inscriptions in a variety of ways that show ingenuity and a certain playfulness. More often than not, the inscription will simply be placed in the background horizontally.

For individual figures, it's always safe to apply the lettering either to the area just above and on both sides of the halo or to use the area of the background near where the halo and shoulders meet. The former is placed in the uppermost corners of the icon and can sometimes appear to be top-heavy, but the latter is often more balanced with the figure.

There are times when the figure itself will not squarely face forward but will have a graceful curve in the stance that throws the whole composition off-balance a bit. In that case, use the inscription to balance the icon by using the negative space in the background on one side or the other.

Sometimes lettering is applied so that the words are laid out vertically rather than horizontally. I rarely find this aesthetically pleasing and avoid it whenever possible. You may have a different thought; both ways are completely acceptable.

When space is limited, another option is to use the borders. This works especially well for very large images of the Mother and Child that have really close, cropped images showing mainly the heads and shoulders in which there is very little background that is not crowded out by the figures or halos. Using the borders in this case extends the image into an area that is usually untouched and perhaps empty. In icons showing large groupings of saints or angels, it's also common to place the inscription within the halos of the individuals portrayed. Naturally, if you are using gold leaf, this adds a level of complexity due to the interaction of materials, but it's possible to overcome these difficulties to create a beautiful icon. (For instance, try a drop of liquid soap in your paint when it seems to bead up or will not adhere to the gold.)

My only warning is that you resist the urge to label and explain too much. No need to turn your icon into a billboard or to control what viewers will think and feel when they stand in prayer before it. You should err on the side of less rather than more and resist any urge to circle the image with an appropriate scriptural reference or to place little fluttering banners with words like "alleluia" or "peace" somewhere in the icon. We need to trust the images and let them say what they need to without our commentary. As one of my mentors says, "When a sentence will do, don't use a paragraph. When a word will do, don't use a sentence, and when silence will do, don't use words." So I suppose all these words are my attempt to convey that you should use as few words as possible, place them well, do your best, and move on.

It may seem as if everything in an icon is legislated and controlled by canons that novices think can be found in some mysterious rule book. Well, there is no rule book, and sometimes rules are not as black and white as they seem. Stick around and you'll understand. For example, inscriptions on icons are significant, but their placement is not. A quick glance at any decent book containing prints of icons from different centuries and locations will reveal that the inscription is simply another way to clarify the identity of the saint or the meaning of the scene. Although there's probably an elaborate theological explanation out there somewhere, it has usually been developed after the fact.

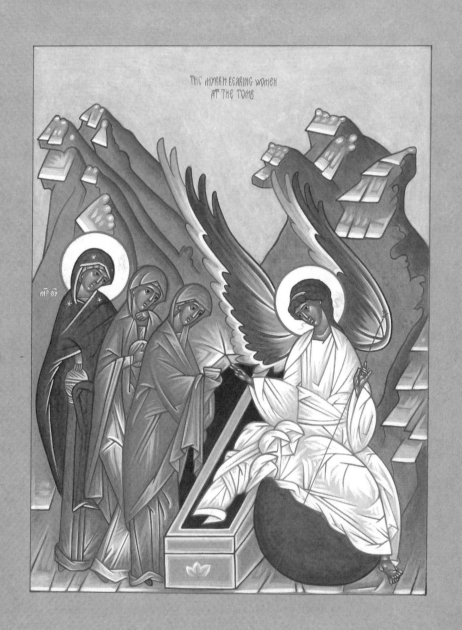

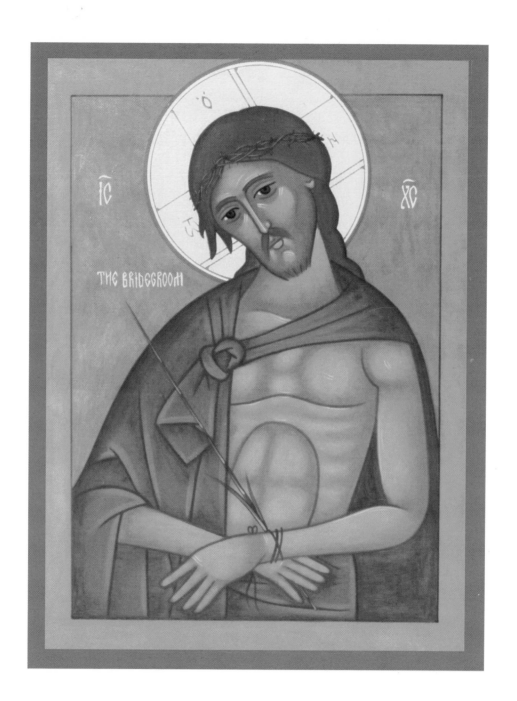

Christ the Bridegroom

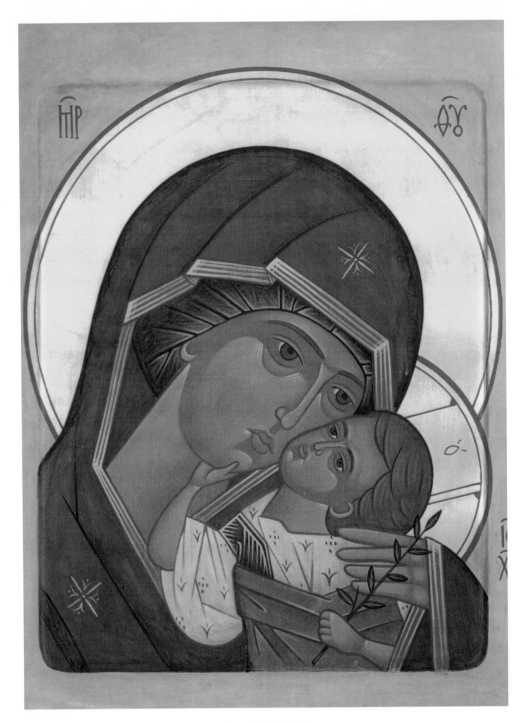

Mother of God of Peace

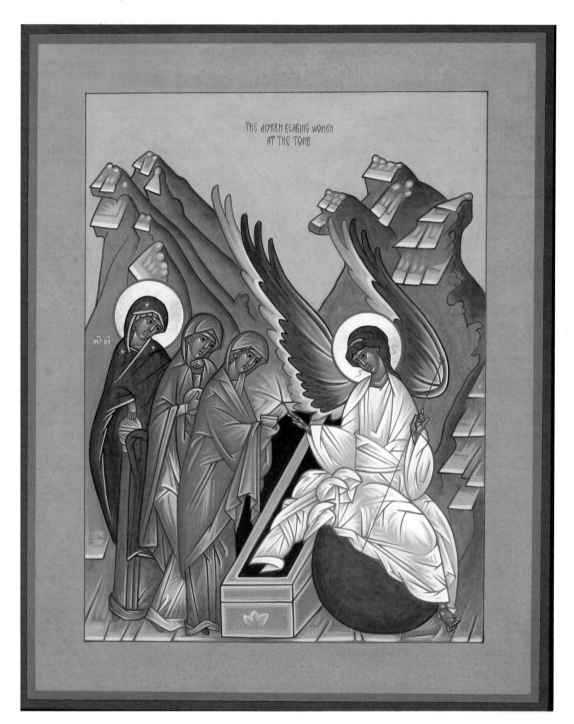

The Myrrhbearing Women at the Tomb

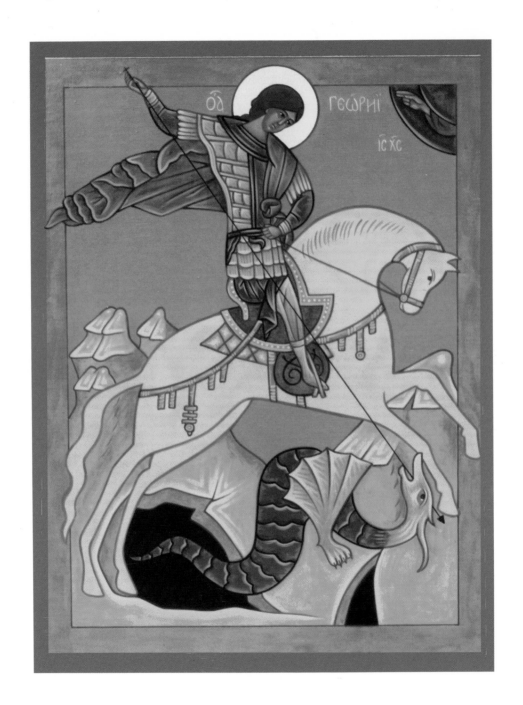

Saint George and the Dragon

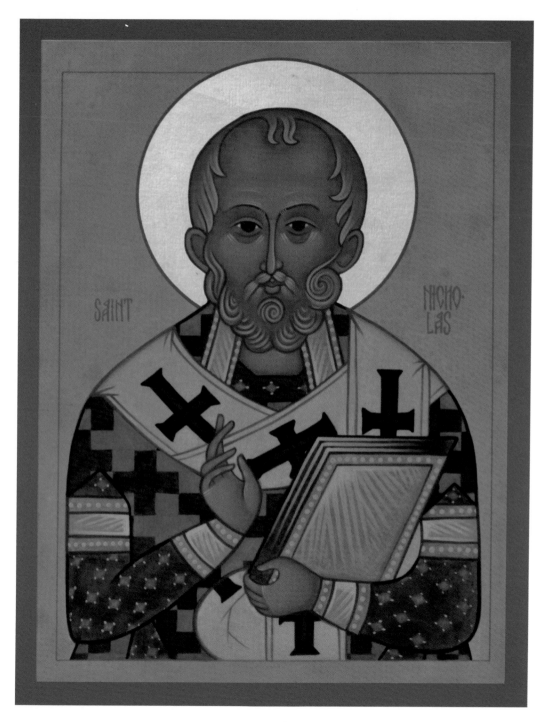

Saint Nicholas

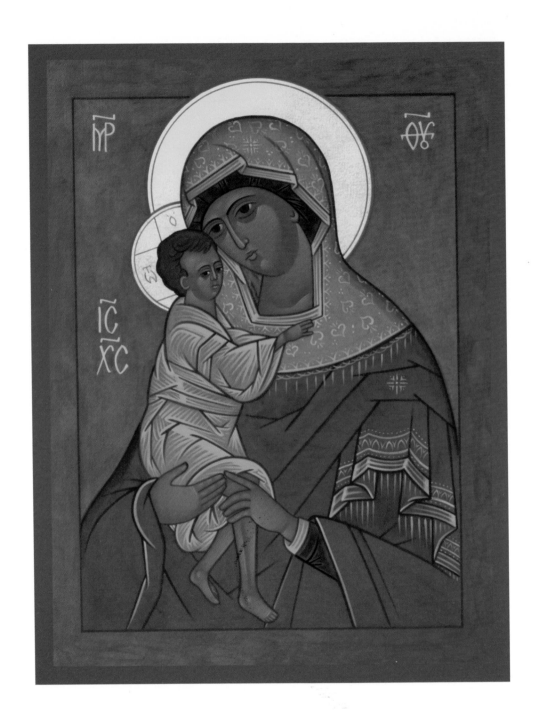

Mother of God, Seeker of the Lost

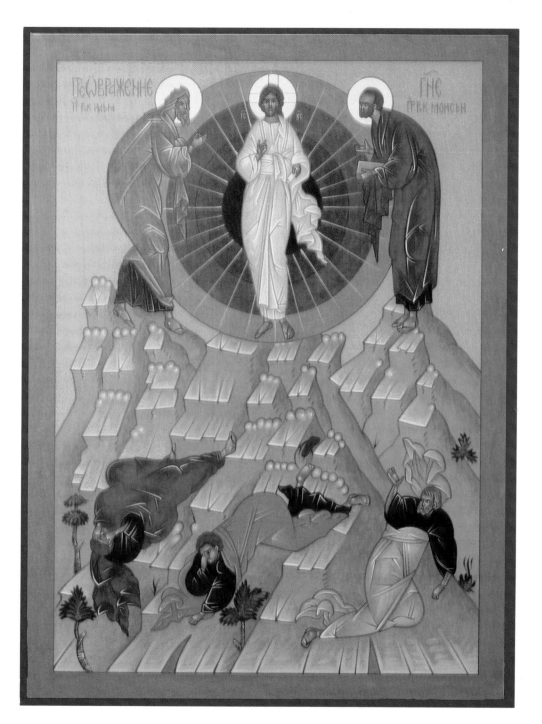

The Transfiguration

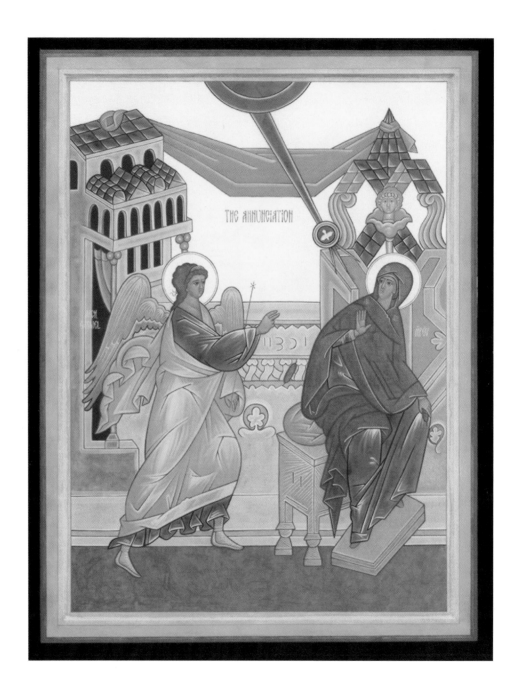

The Annunciation

Four Icons Step-by-Step

Each icon in this section introduces a new skill. The Transfiguration will help you play a bit with rocky mountains and full figures; the Annunciation will give you a chance to paint two full figures, one with wings, as well as architectural features; Saint Nicholas provides ample opportunity to practice garments with all sorts of decorations; and the Bridegroom offers an opportunity to paint musculature. Add these skills to what you've already learned from *A Brush with God* (for example, heads with and without beards, gray hair, some simple garments) and you should be able to paint almost any icon you wish by simply breaking it down into the parts presented in these two volumes.

Note: Each icon begins with the same steps:

1. Trace the drawing.

2. Transfer the image to the panel.

3. Paint in the drawing's lines.

4. Apply Yellow Ochre/Oxide/Earth (sometimes I use orange) washes to the panel.

What follows in the text about the four icons are specific directions for each one and maps/illustrations for where to place each successive highlight. (See insert for color renderings.)

When I paint, I usually move from what is farthest away to the parts that appear closest to the viewer. This means that I paint the sky, then landscapes and architectural features, then furnishings, and finally the figures, starting with the garments and ending with parts of the body. Working this way means I don't have to paint around the figures and risk splattering paint on the really important parts of the icon in the process. Less fixing time means that I can work more efficiently and cleanly. Try it!

The Transfiguration

"Jesus took Peter, James, and John his brother, and led them up a high mountain by themselves. And he was transfigured before them; his face shone like the sun and his clothes became white as light." (Matt 17:1–2)

The icon reproduced here is a copy of a Transfiguration dating from the latter part of the fifteenth century in Novgorod, Russia, where it was originally a part of an iconostasis in the Church of the Dormition-in-Volotovo-Field.

The image of the Transfiguration is very important within the context of Byzantine iconography for spiritual and practical reasons. Spiritually, the experience of Jesus' transfiguration on Mount Tabor relates directly to the whole movement of the Christian life: we are all invited to be transformed and transfigured through the grace of God working in our lives, just as Jesus was transfigured on that mountaintop. For a more thorough discussion of this subject, consider reading the writings of the fourteenth-century hesychast (see the glossary) and saint, Gregory of Palamas. He, along with other Christian mystics stress that we see God shining in and through Jesus, and especially at the event on Mount Tabor. As Chistians we hope and pray to one day shine with that same radiance at our own transfiguration by God's grace.

Along with that—and this part is really exciting—as iconographers it's our task to communicate or recreate the experience of what it must have been like to see the face of Jesus glowing with the uncreated light of God's presence. In other words, we get to paint *glory*. In this icon we're challenged to balance the human and divine natures of Christ in our rendering of his transfigured countenance. That's no small task but it is a necessary exercise for iconographers to take on because that's exactly what we do in every icon we paint.

On a more practical note, this icon is extremely useful because it provides lots of practice in painting mountains and rocks. It will also give you wonderful opportunities to apply geometric highlights to garments to render the appearance of arms and legs under and shining through the folds of the cloth. Plus, you get the added challenge of painting small faces. Your efforts will stretch you beyond your comfort zone; even your "mistakes" will serve to teach you.

This icon is designed for a panel whose dimensions are based on a ratio of 3:4, and I recommend painting it on a panel that's either 12 x 16 inches or 15 x 20 inches. Using a photocopy machine with a zoom feature, you can easily enlarge the drawing provided here to the proper size. You may have to copy the image in parts depending on the size of the paper that the machine uses, but you can work that out.

Here are the steps to follow:

Note that the asterisks indicate Jo Sonja paint colors.

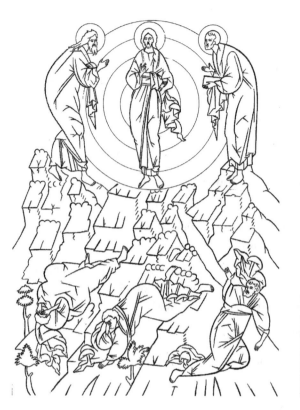

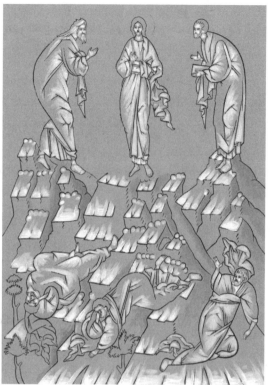

1. Paint in the base colors for each area. Do this by applying several thin (but not watery) layers of paint in each color area with short, multidirectional brush strokes. Layering will level out the color as you go. Pay no attention to folds and other details; just fill in the areas, trying to create intense color without losing transparency. You should be able to see the lines of the folds and the faces through your paint at all times.

 - Sky: a light yellow-white (Turner's Yellow*).

 - Mountains on either side: earthy orange (Gold Oxide*).

 - Center mountain: yellow-green (Moss Green*).

 - Circles behind the Christ figure: dark blue (Storm Blue*) for the center circle, then add a bit of white or yellow-white (Naples Yellow*) for the second, then more white or yellow-white for the next, and so on.

- Elijah figure (top left): green (Green Oxide*) plus a bit of yellow for outer garments and blue (Storm Blue*) for inner garment.

- Christ figure: off-white (Opal*) on all garments.

- Moses figure (top right): maroon (Indian Red*) outer garment and blue (Storm Blue*) inner garment.

- James (bottom left): maroon (Indian Red*) outer garment and blue (Storm Blue*) inner garment.

- John (bottom center): red (Napthol Red Light*) outer garment and blue (Storm Blue*) inner garment.

- Peter (bottom right): red-orange (Norwegian Orange*) or earthy orange (Gold Oxide*) outer garment and blue (Storm Blue*) inner garment.

- All skin and hair areas are covered with sankir (Yellow Ochre/Earth/Oxide* plus Napthol Red Light* and Green Oxide*) color and then brown hair areas on head only (no beards or moustaches) are washed with a reddish brown (Burnt Sienna*).

- Border: sankir (see skin area color above).

- Outer border (1/4 inch all around the edge and sides of panel): brick red (Red Earth*).

2. Now apply shadowing and highlights. Please refer to the "map" for the first highlight to get an idea of the placement and area of the highlight. For second and third highlights, simply shrink the area you want to cover. Expect to paint several layers of each shadow and highlight. Again, keep your paint thin and transparent so the transitions of color will be subtle (especially on skin areas).

- Mountains: shadow all with reddish brown (Burnt Sienna*) washes and highlight all with yellow plus a touch of white (Turner's Yellow*).

- Green garments: no shadow. For highlights, add a bit of yellow and white to the green base color and then more yellow and white for each additional highlight.

- Blue garments: no shadow. For highlights add a bit of yellow and white to base color and then more yellow and white for each additional highlight. (The addition of some yellow keeps it from becoming too chalky.)

- Red garments: shadow with reddish brown (Burnt Sienna*) wash and highlight with yellow plus a touch of white (Turner's Yellow*).

- Orange garments: highlight with yellow plus a touch of white (Turner's Yellow*) and add a bit of white for last highlight.

- Maroon garments: blue (Storm Blue*) plus some yellow and white (Turner's Yellow*) for first highlight and then add a bit more yellow and white for each additional highlight. This is called a double reflection (one color highlighted with a different color).

- White garments: bright white (Warm White* or Titanium White*) for a fine highlight against fold lines.

- Skin areas: highlight with a tangerine or marigold orange (Yellow Ochre/Earth/Oxide* plus Napthol Red Light*), then use only Yellow Ochre/Earth, then add a bit of white for the last highlight. Add more white for enliveners and whites of eyes.

- Peter and Elijah's gray hair: add white to sankir, then a bit more white.

- Pinstripe between image and border: reddish brown (Burnt Sienna*).

- Pinstripe between border and outer border: off-white (Opal*).

3. Original lines of the drawing are now reinstated. The easiest way to do this is to mix the base color of any specific area with a darker color, like brown or blue, to create a deeper shade of the base color and use that for reinstating your lines. Black could be used, but I prefer something less heavy and powerful.

55

4. Details are added at this time:

- Vegetation: green plus a touch of brown.

- Rays on circles: yellow plus a touch of white (Turner's Yellow*).

- Inscriptions: red (Red Earth* or Norwegian Orange*).

- Eyebrows, beards, eyebrows, and moustaches (except for gray hair which is darker sankir): reddish brown (Burnt Sienna*).

- John's sandal: brown (Burnt Sienna* or Brown Earth*).

- Sandal lines of other figures: brown (Burnt Sienna* or Brown Earth*).

5. You may now add gold leaf to the halos, if you wish. If the halos are painted, use yellow with a touch of white added (Turner's Yellow*). Next, lay in the pinstripe that forms the outline of the halo with brick red (Red Earth*). Once that's done, go back and reclarify the outline of the head and shoulders so that there's a clear line between the gold/yellow and the paint.

6. Make any necessary corrections and varnish the icon.

In my workshops, I don't allow folks to fix things until the end of the process because many "mistakes" are corrected by the process. In addition, waiting gives everyone a chance to practice a bit of patience and short-circuits tendencies toward perfectionism. Left unchecked, that little character flaw could keep us so busy correcting things that we never get around to painting the icon. Many of the problems that haunt us along the way are hardly noticeable at the end of the process because layers and layers of color often camouflage or annihilate our peccadilloes. So ask yourself: Do I want to learn to fix mistakes, or do I want to learn to paint icons?

THE ANNUNCIATION

"In the sixth month, the angel Gabriel was sent from God to a town of Galilee called Nazareth, to a virgin betrothed to a man named Joseph, of the house of David, and the virgin's name was Mary. And coming to her, he said, "Hail favored one! The Lord is with you. . . . You will conceive in your womb and bear a son, and you shall name him Jesus." (Luke 1:26–31)

Our icon of the Annunciation is a copy of one of the double-faced panels (also called "tablets") in the Cathedral of Saint Sophia in Novgorod, dating from the fifteenth or early sixteenth century. The announcement of God's invitation to the virgin and Mary's "may it be done to me according to your word" (Luke 1:38) is often depicted on the royal doors of the iconostasis in Eastern churches because in that moment the incarnation became a reality within human history. Just as Christ comes to his people through the Annunciation and the Incarnation, he comes to them at every liturgy when the priest, representing the person of Christ, steps through the royal doors to bless, to proclaim the Gospel, and to offer them communion in the Sacrament of Christ's Body and Blood.

The Annunciation icon proclaims that *this* is the moment, *this* is the place, and *this* is the time when everything comes together, when heaven and earth unite, and the dance of the Incarnation begins among us again and again and again until all creation is swept up, redeemed, and transformed into God's reign. That's overwhelmingly beautiful. Savor that as you paint this icon.

On a more practical level, there is plenty of architectural detail in this icon for practicing highlighting and shadows on walls, roofing tiles, and details such as the human-headed column behind and above the Theotokos (Mary, the God-Bearer). Also notice the wonderful rendering of the highlight on the leg of the Archangel Gabriel, which will allow you to experiment with the fleshing-out of the

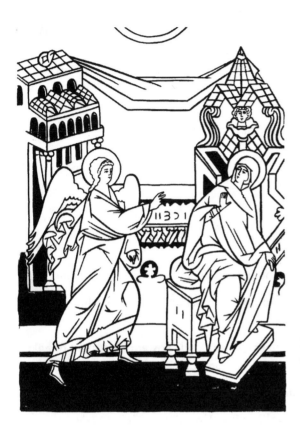
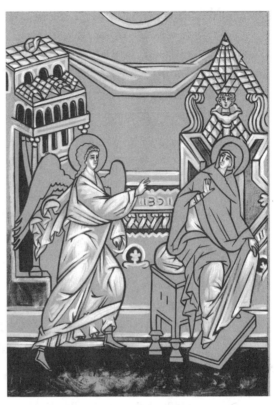

human form by using geometric shapes in lighter and lighter shades of color applied in layers on one another. The Novgorod original also includes decoration on the surface of the ground through the use of some wonderfully unique designs that were omitted in my interpretation of this icon. It's a uniquely Novgorodian element that always leaves people asking what the symbols on the ground might mean. I've used this technique on several other panels I've painted over the years but am unsure of the meaning, if there is any, of doing this. After conferring with other iconographers, I've found that no one else seems to know either, so all I can offer is that the consensus is it breaks up what is normally the flat area of color and makes the ground more special (transfigured flooring?). Or perhaps it might be an attempt to make the surface look a bit more like a lawn. Regardless of the reasoning, it's interesting. You can easily check out this pattern in any good book on Novgorod icons and decide for yourself whether to include it or not.

This icon is designed for a panel that has a ratio of 3:4 and I suggest either the 12 x 16 inch or 15 x 20 inch size. You can easily enlarge this drawing on any photocopier with a zoom feature.

1. Paint in the base colors for each area. Do this by applying several thin (but not watery) layers of paint in each color area with short, multidirectional brush strokes. Layering will level out the color as you go. Pay no attention to folds and other details; just fill in the areas, trying to create intense color without losing transparency. You should be able to see the lines of the folds and the faces through your paint at all times.

 - Ground: sage green (Olive Green* plus Provincial Beige*).

 - Sky: yellow plus a touch of white (Turner's Yellow*).

 - Building on the far left: light sage green (Olive Green* plus Provincial Beige*) plus a touch of white.

 - Building on the far right and Gabriel's outer garment: flamingo pink (Napthol Red* plus Turner's Yellow*).

 - Wall in the center: tan (Fawn*). (Note: Don't bother with windows until you finish buildings.)

 - Drapery hung between buildings, curtain in doorway behind Gabriel, cushion beneath Mary, Mary's shoes: red (Napthol Red Light*).

 - Roof tiles, Angel's inner garment, Mary's inner garment and shower cap, capital of pillars behind Gabriel, and semicircle in sky: blue (Storm Blue*).

 - Chair, footstool, under wing: earthy orange (Gold Oxide*).

 - Skin (and hair), outer wing, and border: sankir (Olive Green* plus Gold Oxide*).

 - Mary's outer garment and pillar: deep red or maroon (Indian Red Oxide*).

 - Border: sankir or straw color (Raw Sienna*).

 - Outer border (1/4 inch all around) and edge of panel: maroon or brick red (Red Earth* or Indian Red Oxide*).

2. Now apply shadowing and highlights. Please refer to the "map" for the first highlight to get an idea of the placement and area of the highlight. For the second and third highlight, simply shrink the size of the area you cover, placing each highlight on top of the one before. Expect to paint several layers of each shadow and highlight. Again, keep your paint thin and transparent so the transitions of color will be subtle (especially on skin areas).

 - Building on far left: shadow with base color used for ground color on side of building; keep it thin and transparent.

58

- Building on far right and wall in center: shadow with a wash of a reddish brown (Burnt Sienna*). Note: While you have the Burnt Sienna out, tint Gabriel's hair with it.

- Highlight buildings and Gabriel's pink robe and lower wings with a transparent white (Unbleached Titanium*).

- On Gabriel's robe and the pink buildings, add a wash or glaze of the pink base color over the first highlight and then highlight again with the white. Note: On architectural features, paint one wide highlight line next to the dark lines, then a thinner one right beside the dark lines, using a lighter color to make it pop.

- On reds: yellow plus a touch of white (Turner's Yellow*) and wash over it with a thin layer of red (Napthol Red Light*).

- On all blues: a lighter blue or gray blue-green (Antique Green*) for the first highlight and then use the same transparent white as before (Unbleached Titanium*).

- On Gold Oxide* areas and upper wings: yellow plus a touch of white (Turner's Yellow*) for hatching highlights and tops of footstool and chair. You can also add some white (Unbleached Titanium*) for the highest highlight on these two areas.

- Skin areas: Yellow Ochre/Earth/Oxide* plus red (Napthol Red Light* or Vermillion*), which I often refer to as tangerine orange or marigold, then use just Yellow Ochre/Earth/Oxide,* then add a bit of white (Unbleached Titanium*) to the yellow for the last highlight. Add even more white for the enliveners and glistens in the eyes.

3. Original lines of the drawing are now reinstated. The easiest way to do this is to mix the base color of any specific area with a darker color, like brown or blue, to create a deeper shade of the base color and use that for reinstating your lines. Black could be used, but I prefer something less heavy and powerful.

4. You may now add gold leaf to the halos, if you wish. If the halos are painted, use yellow with a touch of white added (Turner's Yellow*). Next, lay in the pinstripe that forms the outline of the halo with brick red (Red Earth*). Once that's done, go back and reclarify the outline of the head and shoulders so that there's a clear line between the gold/yellow and the paint.

5. Details are now added.

 - Gabriel's staff should be the same red as the lettering (Red Earth* or Norwegian Orange*).

 - The embroidery lines and stars on Mary's robe are yellow plus a touch of white (Turner's Yellow*).

- Designs on the floor: base color plus blue (Storm Blue*).

- Dove on the beam from heaven: white (Unbleached Titanium*).

- Pinstripe between image and border: reddish brown (Burnt Sienna*).

- Pinstripe between border and outer border: white or yellow-white (Opal* or Naples Yellow*).

6. Make any necessary corrections and varnish the icon.

SAINT NICHOLAS

> *"Almighty God, in your love you gave to your servant Nicholas of Myra a perpetual name for deeds of kindness both on land and sea: Grant, we pray, that your Church may never cease to work for the happiness of children, the safety of sailors, the relief of the poor, and the help of those tossed by tempests of doubt or grief, through Jesus Christ our Lord, who lives and reigns with you and the Holy Spirit, One God, forever and ever. Amen."[1]*

Saint Nicholas is loved throughout the Eastern church and indeed throughout the world. His feast day is celebrated on December 6, and even in the West his memory is honored, although often in a drastically secularized and commercialized form as Santa Claus. Nicholas served as the Bishop of Myra in what is now Turkey during the third century after suffering torture and imprisonment for his faith during the persecutions of the Emperor Diocletian. He was one of the fathers of the Council of Nicea convened by the Emperor Constantine in 325 AD to settle the Arian controversy and the question of whether Christ was truly God or merely a creature like the rest of us who was given divine status at some point in time. Nicholas was removed from the council and barred from the episcopacy for some time after giving Arius a poke in the nose during the heated debates at the council. He was later restored to the office of bishop and is remembered as a model for all bishops (but probably not for the "poke in the nose" part). Nicholas is celebrated as a defender of orthodoxy and a model of episcopal service, as well as the patron of sailors, prisoners, and orphans.

The prototype of this icon of Saint Nicholas was painted in 1294 by Aleska Petrov and commissioned by Archbishop Clement of Novgorod as a dedicational image for a church named in honor of this beloved bishop and saint. The icon is described as both majestic and solemn in the ways it communicates Nicholas's "wondrous unearthly strength [rather than] his intellectual refinement."[2]

The version presented here is a dramatically simplified variation of the original that eliminates everything from the original except Saint Nicholas himself (that is, the throng of saints around the border, the images of Christ and the Virgin next to the halo, and stylized imitation of gems on the halo itself).

I'm including this image even though an icon of Saint Nicholas appears in *A Brush with God* because this version will give you a chance to experiment with garments and a book cover with a series of decorative patterns and designs. In this icon, almost no surface of Nicholas's clothing or Gospel book is left untouched by crosses, geometric shapes, jewels, and pearls. Even though the decorative elements are lavishly generous in this icon, they are not overwhelming or garish because of the sense of unity and balance with the colors introduced into the icon. You'll be using a relatively limited palette combined in a variety of ways that are harmonious and pleasing to the eye. Nothing in this composition competes for attention or requires shifting our gaze away from the face of this beloved saint. An added bonus is that once again you get to paint a bearded face with a balding forehead and gray hair. You can never have too much practice with that.

This icon, like the others, is based on a 3:4 ratio and I suggest that you paint it on a 12 x 16 inch panel so you can manage the decorations on the garments without having to use a microscope.

1. Paint in the base colors for each area. Do this by applying several thin (but not watery) layers of paint in each color area with short, multidirectional brush strokes. Layering will level out the color as you go. Pay no attention to folds and other details; just fill in the areas, trying to create intense color without losing transparency. You should be able to see the lines of the folds and the faces through your paint at all times.

 - Background and border: slime green (Turner's Yellow* plus a touch of Carbon Black* and a bit of Napthol Red Light*).

 - Outer garment: maroon (Indian Red Oxide* or Brown Madder*).

 - Inner garment, collar of maroon garment, and page ends of book: blue (Storm Blue*).

 - Omiphorion/pallium: off-white (Opal*).

 - Skin and hair areas: sankir (Yellow Ochre/Earth/Oxide* plus Green Oxide* plus Napthol Red Light*).

 - Book cover, bands running down from neck and edges of cuffs/armbands: straw color (Raw Sienna* or Burnt Sienna* plus Yellow Oxide*).

 - Center portion of cuffs/arm bands: earthy orange or reddish orange (Gold Oxide* or Norwegian Orange*).

 - Outer border (1/4 inch all around) and edges of panel: deep red or brick red (Indian Red Oxide* or Red Earth*).

 - Halo (if not gold leafed): Turner's Yellow*.

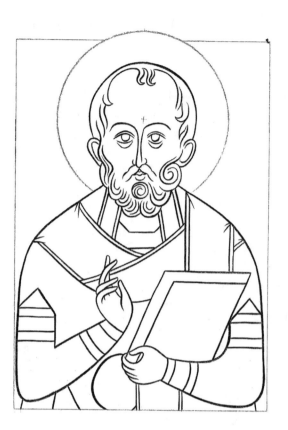

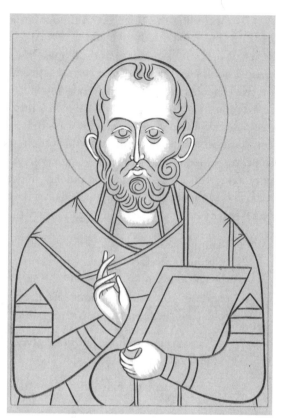

2. Now apply shadowing and highlights. Please refer to the "maps" for each successive highlight to get an idea of the placement and area of each highlight. Expect to paint several layers of each shadow and highlight. Again, keep your paint thin and transparent so the transitions of color will be subtle (especially on skin areas).

- Shadow on edges of omiphorion/pallium: straw color (Raw Sienna* or Burnt Sienna* plus Yellow Oxide*).

- Highlight on cuffs/armbands, book cover, page ends of book, and bands running down from neck: yellow plus a touch of white (Turner's Yellow*).

- Skin areas: Yellow Ochre/Earth/Oxide* plus red (Napthol Red Light* or Vermillion*), which I often refer to as tangerine orange or marigold, then use just Yellow Ochre/Earth/Oxide,*

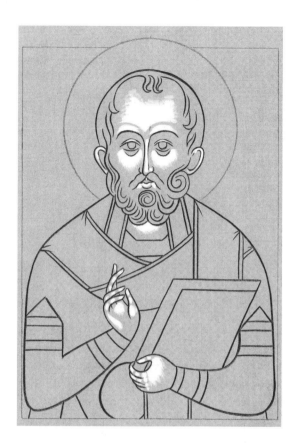
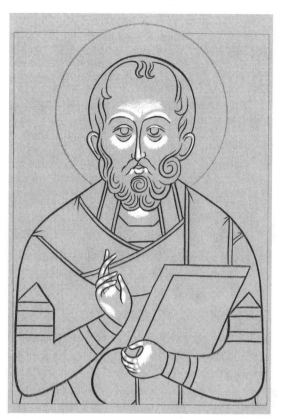

then add a bit of white (Unbleached Titanium*) to the yellow for the last highlight. Add even more white for the enliveners and glistens in the eyes.

- Hair on head: shadow with dark color (Raw Umber*) and highlight with a straw color (Burnt Sienna* plus Yellow Ochre/Earth/Oxide*).

- All hair areas: sankir plus a touch of off-white (Opal* or Unbleached Titanium*); add more off-white for second highlight, and then pure off-white for the last highlight.

3. The details are added at this point.

- Pearls: off-white (Opal* or Unbleached Titanium*).

- Irises: red-brown (Burnt Sienna*).

- Crosses on omiphorion/pallium, pupils, outline of irises, and upper eyelash: dark (Storm Blue* plus Brown Earth*).

- Highlight on omiphorion/pallium crosses: yellow plus white (Turner's Yellow*) or straw color (Raw Sienna*).

- Cross pattern on maroon garment: dark blue (Storm Blue*).

- Diamond patterns on blue garment: straw color (Raw Sienna*) centers with red/orange (Norwegian Orange*) edges, then pearls as above.

- Lettering: white-yellow (Naples Yellow*).

- Pinstripe between border and image: slime green plus a touch of blue (Storm Blue*).

- Pinstripe between border and outer border: off-white (Opal* or Naples Yellow*).

4. Original lines of the drawing are now reinstated. The easiest way to do this is to mix the base color of any specific area with a darker color, like brown or blue, to create a deeper shade of the base color and use that for reinstating your lines. Black could be used, but I prefer something less heavy and powerful.

5. You may now add gold leaf to the halos, if you wish. If the halos are painted, use yellow with a touch of white added (Turner's Yellow*). Next, lay in the pinstripe that forms the outline of the halo with brick red (Red Earth*). Once that's done, go back and reclarify the outline of the head and shoulders so that there's a clear line between the gold/yellow and the paint.

6. Make any necessary corrections and varnish the icon.

CHRIST THE BRIDEGROOM

> *"Then the soldiers of the governor took Jesus inside the praetorium and gathered the whole cohort around him. They stripped off his clothes and threw a scarlet military cloak about him. Weaving a crown out of thorns, they placed it on his head, and a reed in his right hand. And kneeling before him, they mocked him, saying, 'Hail, King of the Jews!'"* (Matt 27:27–29)

Back in 1994, when I studied with Nicholas Papas near the monastery where I lived, Nick gave me a small plaque with this image on it. He had painted it many times and had photographic images made to give as gifts. Even though it was only a print glued to a piece of scrap wood, it was one of the most beautiful icons I had ever seen. I still think so today. Over the years, that image has blessed me again

and again. Eventually, I made my own drawing of the image and have now painted it many times myself. Oddly enough, when I visited the monastery at the top of the island of Patmos off the Greek mainland a few years ago, I encountered another image of the Bridegroom. This one was painted by Domenicos Theotocopoulos (who most of us know as El Greco) in the mid-1500s while he was still an iconographer in Greece. It is also a beautifully graceful image with the most elegant curve in the arms as they lay draped over one another. Such beauty!

During the season of Lent the year Nick gave me that small icon, I prayed with it every day and allowed that image to teach me about the passion, death, and resurrection of Jesus Christ. This icon has taught me that the message of Christ's suffering and death is not primarily about pain, but about love and how sometimes the cost of great love is great suffering. Jesus loved God. Jesus loved us. That love would not permit him to run away or to back down from the truth, not even to save his own life. Instead, he embraced the consequences of the great love that burned within him. As it says in the First Letter of Peter: "Christ . . . suffered for you, leaving you an example that you should follow in his footsteps. . . . When he was insulted, he returned no insult; when he suffered, he did not threaten; instead he handed himself over to the one who judges justly. . . . By his wounds you have been healed" (1 Pet 2:21, 23–24).

This image speaks to me of a love stronger than death and even stronger than the *fear of death* that keeps so many of us clinging to our illusions of control and power. Its message rages against the night and all the powers of darkness and the subtle ways we force others to stay in the prisons we fashion for them. Once a person no longer fears death, he or she is amazingly free and powerful and alive. Jesus Christ is the model of such a person. Musician John Michael Talbot has put Peter's words to music in which he invites us to "let all who seek the true path of peace simply come to follow in the footsteps of this man who laid down his life when threatened with hatred. And so he came to live in the blessings of love. And so he came to live forever."[3]

I've included this icon to give an example of how muscles of the body are rendered in iconography. They may not be anatomically exact, but should be fairly close to reality. An image of Saint Mary of Egypt or the Crucifixion would also serve this purpose very well. Notice that the transitions from shadow to highlights on skin areas tend to be softer and more subtle than on garments in which you can create really dramatic highlights. It takes some practice to develop smooth layering on various areas of the human body. Be patient with yourself if you don't get it the first time. If you're paying attention, every attempt will teach you something more about how to do this better the next time. Also, the fact that several details in this icon (the crown of thorns, the reed, the ropes that bind Christ's hands) will be added *after* the figure and its drapery are completed, will help you to see how to work in a more efficient manner by minimizing the need to paint around small elements in any composition. This lesson might not be a part of the canons of iconography but will certainly make your life a bit simpler.

Paint this icon on a panel whose dimensions are based upon the standard 3:4 ratio. It will do nicely on a 9 x 12 inch panel or even the 12 x 16 inch size. I hope you find it as engaging as I have over the years.

65

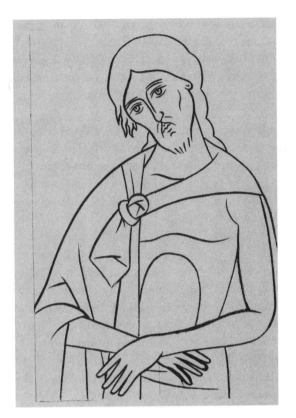

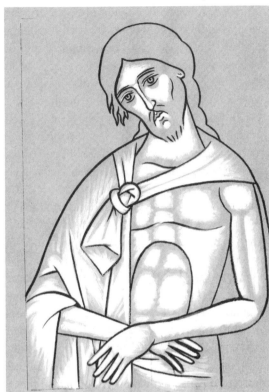

At the risk of being repetitious, please note: On this icon we will omit the crown of thorns, the reed, and the bindings on the wrists until we are almost finished. It is easier than working around them.

1. Paint in the base colors for each area. Do this by applying several thin (but not watery) layers of paint in each color area with short, multidirectional brush strokes. Layering will level out the color as you go. Pay no attention to folds and other details; just fill in the areas, trying to create intense color without losing transparency. You should be able to see the lines of the folds and the faces through your paint at all times.

 - Background: gray blue-green (Antique Green*).

 - Cloak: deep red or maroon (Indian Red Oxide* or Brown Madder*).

 - Skin and hair areas: sankir (Olive Green* plus Gold Oxide*).

 - Hair on top of head: wash with reddish brown (Burnt Sienna*) after sankir is done.

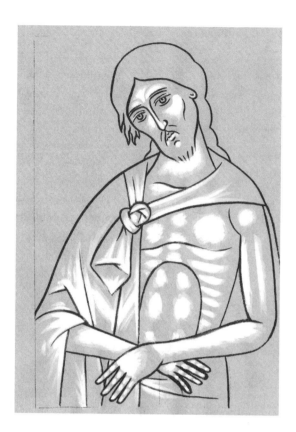

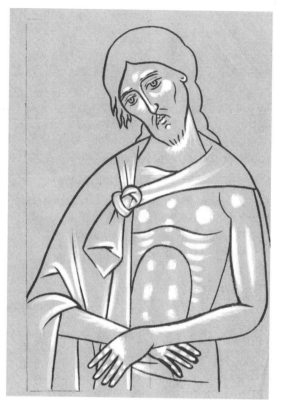

67

- Border: sankir (above) or yellow-green (Moss Green*).

- Outer border (1/4 inch all around) and edges of panel: deep red or brick red (Indian Red Oxide* or Red Earth*).

- Halo (if not gold leafed): Turner's Yellow*.

2. Now, apply shadowing and highlights. Please refer to the "maps" for each successive highlight to get an idea of the placement and area of each highlight. Expect to paint several layers of each shadow and highlight. Again, keep your paint thin and transparent so the transitions of color will be subtle (especially on skin areas).

- Sky: blue (Storm Blue*) is used as a wash and blended down from the top edge of the image inside the border. This color fades to nothing about halfway down toward the figure. (This is completely optional.)

- Cloak: shadow with a dark color (Raw Umber*) and highlight with layers of red (Napthol Red Light*).

- Skin areas: Yellow Ochre/Earth/Oxide* plus red (Napthol Red Light* or Vermillion*), which I often refer to as tangerine orange or marigold, then use just Yellow Ochre/Earth/Oxide,* then add a bit of white (Unbleached Titanium*) to the yellow for the last highlight. Add even more white for the enliveners and glistens in the eyes.

- Hair on head: shadow with dark color (Raw Umber*) and highlight with a straw color (Burnt Sienna* plus Yellow Ochre/Earth/Oxide*).

3. Original lines of the drawing are now reinstated. The easiest way to do this is to mix the base color of any specific area with a darker color, like brown or blue, to create a deeper shade of the base color and use that for reinstating your lines. Black could be used, but I prefer something less heavy and powerful.

4. Details are now added.

- Reed and crown of thorns: base color is green (Green Oxide*). The shadow is green plus any dark color (Raw Umber*) and the highlight is a yellow green (Moss Green*).

- Ropes that bind the wrists are dark brown (Brown Earth* or Burnt Sienna* plus Raw Umber*) .

- Beard, moustache, eyebrows, and irises of eyes: reddish brown (Burnt Sienna*). Do subtle washes for the beard so that it is deeper at the bottom and fading into the face. This is very important.

- Pupils, upper eyelash, and around the iris: a very dark color (Storm Blue* plus Brown Earth*).

- Lettering/inscription: red (Red Earth* or Norwegian Orange*).

- Pinstripe between image and border: reddish brown (Burnt Sienna*).

- Pinstripe between border and outer border: off-white (Opal* or Naples Yellow*).

5. You may now add gold leaf to the halos, if you wish. If the halos are painted, use yellow with a touch of white added (Turner's Yellow*). Next, lay in the pinstripe that forms the outline of the halo with brick red (Red Earth*). Once that's done, go back and reclarify the outline of the head and shoulders so that there's a clear line between the gold/yellow and the paint.

6. Make any necessary corrections and varnish the icon.

And So . . .

By painting the icons in this book, I hope you'll build on techniques presented in *A Brush with God* and thereby add to your repertoire of iconographic skills. Once you have mastered faces with and without beards, brown hair and gray hair, painting large and small figures, rocks, mountains, landscapes, architectural features, furniture, embroidered garments, jeweled books, and muscles, you've pretty much got it. Now all you have to do is practice for a couple of years so you can master the technical part, or at least be well on your way. But remember that there is more to being an iconographer than technique. Don't forget the other parts of this vocation: Prayer, study, participation in the life of your faith community, and service to others. Not even the best iconographers are exempt from any of these requirements.

We have been called to an exceptionally grace-filled and fulfilling role within the Body of Christ, one for which we should be thankful every day. Still, in the final analysis, we are simply Christians working out our salvation shoulder-to-shoulder with all our sisters and brothers on the journey. Let the example of the men and women whose images you paint teach you. Allow them to love you into the fullness of life. Be transfigured and transformed and made new in the image of Christ, the first icon of the Father.

I'm so grateful to be your teacher.

— AFTERWORD —

I'm now sitting in a small room at Glenstal Abbey near Limerick, Ireland, where I've come to see the icons that the Benedictine monks here have preserved. The collection is small, spanning several centuries and a number of schools, all kept in a small chapel under the abbey church in this isolated part of the Irish countryside.

The monastery itself is a jumble of buildings, some of which are the remnants of a castle while others are quite modern. I was impressed by the monk who took me to see the chapel where the icons are housed. Gregory Collins, OSB, is a Byzantine specialist, a field of study of which icons comprise only a small part. He lights up when talking about these images and their stories—even in the semi-darkness of the little chapel, that was easy to see.

Yes, I visit lots of monasteries. I might even be described as a monastery geek, but that's not a bad thing. The monastics have a great deal to offer those of us who think we live in the *real* world. Their silence, focus, and even ordinariness are treasures we often miss in the midst of all our noise and speed. These are the people who, until recently, gave us icons in the first place. That's not a coincidence.

Each of these little jewels is illuminated by a small light that allows the visitor to approach and examine the icon closely. Some of the icons are amazing examples of the miniature work that was so popular in the sixteenth and seventeenth centuries and of the ornament that became the obsession of iconographers around the same time. Dom Gregory speaks of iconography as a living art with a great deal of variety and the popular error in thinking that this was a frozen, unchanging reminder of a distant past. He even admires the icons from what is often referred to as the decadent periods wherein Russian and Greek icons were almost indistinguishable from Italian oil paintings except for the inscriptions. Even these, Dom Gregory notes, have spiritual value and beauty.

As someone steeped in the belief that the only good icons are the ones that reflect the vision of the iconographers from the fourteenth and fifteenth centuries, the "golden age" of iconography, his

comments make me reconsider what I had taken as fact. Perhaps I need to broaden my views and reconsider the attitudes I had embraced without question about the icons created by our more "Baroque" brothers and sisters. Although I'll probably never paint in that style, maybe I can still learn from and pray with these images? Maybe they have also worked God's will in the lives of some of God's children and my blinders prevented me from seeing that. It's another chance to let go of my pre-conceived notions, to let go and to relearn what I thought I knew. That's the exciting thing about being alive: We can always learn if we remain open.

— APPENDIX A —
Considering Color

Color is one of those things that you just can't get around when you paint anything, especially icons. At an annual gathering, my advanced group decided to play with color a bit. Oddly enough, even these folks get intimidated at the thought of having to mix their own colors. So do I, but I usually get around to doing it anyway. Some of my daring comes from working with good color people like Phil Zimmerman (who loves color), Charles Rohrbacher, and Xenia Pokrovsky's folks. They all helped me to feel a bit less frightened of the horrific results I imagined.

Perhaps my fear is the result of an incident that happened years ago. Phil asked me to mix two colors (a red and black) together to make a dark brown. Somehow I got the ratio backwards and ended up having to mix several gallons before I got the combination just right. It turned out fine, but there was *way* too much of it. But nobody died as a result! And the experience helped me get over my fears—until the next time. Fifteen years later, I had to mix another color from Phil's palette and the angst returned with a vengeance. Once again, everything turned out fine, but I had to really give myself a talking-to before managing to simply combine two or three colors to get what I hoped to create. All's well—so please learn about color. Play with color and get over this fear. And know that I'm talking as much to myself as to you. Be bold—try these experiments with color:

- If you need to make sankir, try mixing some Olive Green* and some earthy orange like Gold Oxide* (Jo Sonja color name). Adjust it with more green if you want it darker and more orange if you want it lighter. If you want a green sankir but not one as dark as you might end up with using this mix, try adding yellow ochre (Yellow Oxide*), some green (Green Oxide*) and a touch of red (Napthol Red Light*). I suspect you'll need to use more yellow and less green to get a medium shade of sankir.

- If your blue base color is too dark, try one of the colors Phil calls "Napkin Green" because it was used for one of his Holy Napkin icons. This is a mixture of Green Oxide,* Jade Green,* and Red Earth* that, when you get it right, is a wonderful gray-green. You can get a similar color by combining Olive Green* and Provincial Beige.* I'll let you fiddle with the ratios—it will be good practice. The result is a great color to use for a number of purposes but for blue garments, it's especially good with lighter blue highlights on top of it.

- If you have a green that's too green or a blue that's too blue, toss in a drop of Red Earth* or Norwegian Orange* or some other red/orange to mute the color a bit. Adding the opposite color on the color wheel will always achieve this.

- If your reds are too red, use a blue or a green to tone them down.

- If you need a maroon that's earthier than what's available in a tube, add some brown or a touch of green to create a warm, earthy tone that still has the look of a maroon.

- Did you know that when you add some yellow (Turners Yellow*) to a black you get a slime green color? That's a wonderful background or border color. If you want to use it to do both, add a touch of blue to the mix to make either a bit different and yet still related to the other.

- How about layering colors? How does a translucent blue look on top of an orange? How does a red look using the same underpainting color? It enriches both in very different ways.

See what I mean? If any of us were really good at mixing colors, we would only require a few tubes of paint or packets of pigments and we could make a whole rainbow of colors. Me? I get mesmerized every time I walk into a paint store. So many colors and so little time. Eventually I learned that I don't have to purchase a tube of every color on the rack. I can mix them.

Consider having a panel that you use exclusively to experiment with colors so you don't have to take that risk with an actual icon. Experiment, clean it off, and reuse the panel later. It's a wise thing to do until you establish your own palette of preferred colors. I tend to like earthy tones whereas an iconographer like Solrun Ness from Scandinavia seems to prefer hot, jewel-tone colors. (Any connection between the long dark winters and her color choices?) Remember that the icon manuals offer only general guides for color because not every variation is universally available. Work with what you have and if you are fortunate enough to have lots of choices, go with what you like and then, discover what works for you. Enjoy the colors.

— Appendix B —
Constructing Drawings

In the past, I have often remarked that icons are constructed rather than sketched, something that reflects the ancient understanding of how mathematical or geometrical proportions fit with what we perceive as harmonious beauty. Often, even without knowing it consciously, we are drawn to patterns in nature as well as in art and architecture. A fundamental understanding of geometric proportion can help you to create your own drawings as well as improve drawings or tracings you're presently using for your icons. Although I am not an expert on this, here's a brief introduction to this body of knowledge.

I invite you to study further as you are able, spending some time especially with Father Egon Sendler's book, *The Icon: Image of the Invisible*. Sendler describes how the ancient Greeks relied on the Pythagorean theory that "everything is arranged by number."[4] This material is echoed (although in Italian) in Lombardo's small text entitled, *L'icona: Manuale di iconografia bizantina*. Byzantine iconographers, in turn, used this mathematical theory to create images of faith with a measurement they called a "module."

Both the length of the nose and the size of the head can be a module for design purposes. To put it as simply as I can, a head is constructed based upon the length of the nose and the body is then designed based upon the size of the head. Sometimes, the image follows what we generally consider as the natural proportions of seven-to-eight heads to construct a human body, but iconographers often stretched the human body and lengthened the legs for a more graceful effect.

To learn how to construct a drawing according to these principles, let's start with the head in a full forward position. You'll need a pencil, paper, ruler, and compass for this exercise:

1. Draw one circle.

2. Using the same center point, draw a second circle that's double the size of the first one.

3. Again, using the same center point, draw a third circle that's three times the size of the first circle.

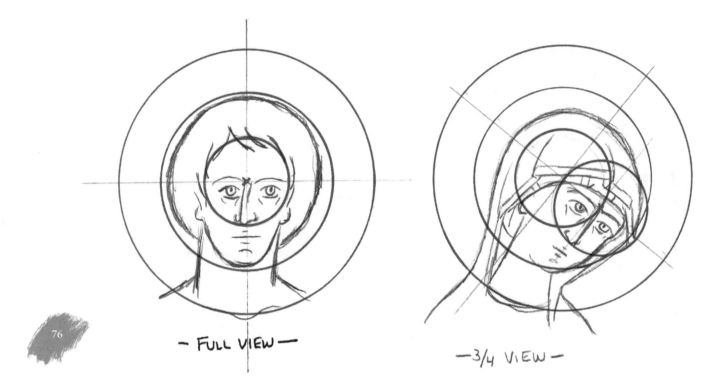

— FULL VIEW —

—3/4 VIEW—

Now you have three concentric circles all based upon the size of the smallest circle. They are all proportionate to one another. Next, we will begin designing the face and head of an adult in the full forward position.

1. From the center point of the circles to the edge of the smallest circle make a "+" by drawing a horizontal and a vertical line.

2. From the center point on the vertical line, draw a nose. Note that almost no icons show a face in the exact forward position. The head is usually turned slightly to one side or another to avoid absolute symmetry, but this doesn't change the formula in any way.

3. From the center point and above each side on the horizontal line, draw arching eyebrows. Slightly below this horizontal line, draw in the eyes with approximately one width of an eye for spacing between them. You may notice there's an inverted equilateral triangle (all sides equal) formed by both pupils and the tip of the nose that helps with spacing. The bottom of

the earlobes are on the same horizontal line as the tip of the nose, while the top of the ear falls roughly along the same horizontal line as the eye. The mouth should be slightly smaller than an eye; placed about the distance of the width of the tip of the nose (including the nostrils); down from the bottom or tip of the nose.

4. The second circle corresponds approximately to the outline of the head and the placement of the chin. (This is only approximate, as you will trim off a bit on the sides to slim down the head a bit; otherwise, it resembles a basketball.) If the head is tilted to one side, trim a bit more off the side to which the head tilts and leave a bit more on the other side.

5. The third circle will approximate the size of the halo and also give you the placement of the collarbone or base of the neck. The halo circle may have to be adjusted slightly, probably on the smaller size. The halo circle usually touches the body in the area where the neck and shoulders meet on both sides of the head.

Note: If we are drawing a head in three quarter view, the first circle is drawn as above but then another center point is created for the nose and forehead by placing a point along the line of the first circle. Even so, the second circle (head outline) and third circle (halo) are still defined by the first point we created.

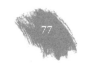

Now you can begin to lay out the measurements for the whole body. Keeping in mind that we will use the standard measurement of eight heads for the whole body length, the torso should be approximately three to four heads in length and the legs about four heads in length. The elbows fall around the third head, the knees at the sixth, and so on. Again, Father Sendler notes how at different periods iconographers have used different formulas to create their drawings and each formula yielded a different effect.[5] Other sources simply divide the body into three units (from the top of the head to the elbows, from the elbows to the knees, from the knees to the bottom of the feet). In this system each unit is three heads in length. Remember, we are setting down guides to help you create visual harmony, not establishing rules to be followed slavishly. Using this very rough explanation, and the other texts cited here, you can begin making your own drawings or refining ones you already have.

Note: The following illustrations are by Kathy Sievers, using Father Sendler's principles of geometric proportion and placement.

Panel 2:5
plus borders

y_3

y_{12}

y_3 y_4

8 heads tall
r Nose $1/12$ ~
width of
entire panel

Panel 2:5
plus borders

HEAD CIRCLE
NOSE CIR.

Halo radius
$2 \frac{7}{8}$ NOSE LENGTHS

Prototype
St Paul by
Nikolay Bogdanov
Modern Orthodox
Icon p 57

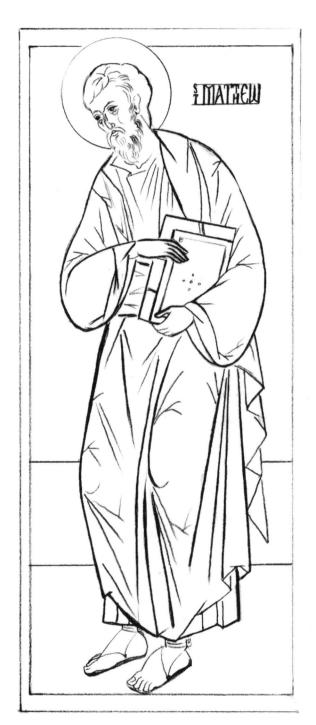

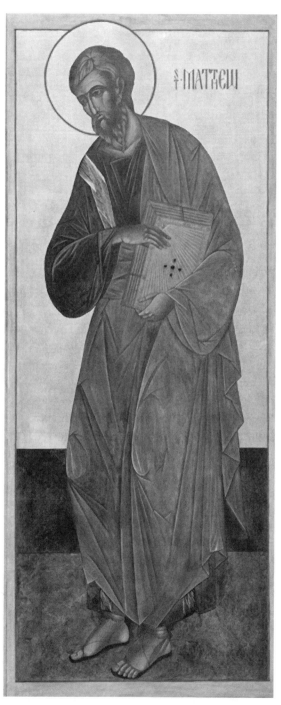

79

More Icon Controversies
The Egg Thing

"For if this endeavor or this activity is of human origin, it will destroy itself. But if it comes from God, you will not be able to destroy them; you may even find yourselves fighting against God." (Acts 5:38–39)

For years, I have listened to our friends who paint with egg tempera dismiss, disqualify, and disparage those of us who use acrylic to create Byzantine icons. For years I have agreed that egg tempera is an excellent and even a delicious medium, because it is. I have tried to understand the esoteric explanations of the symbolic meaning of egg, water, vinegar, powdered pigments/earths, and so on. I have remained silent when some iconographers have insisted that icons can only be created with egg tempera and that everything else is a forgery. At times they even refuse to acknowledge that the icons we paint are *real icons* (whatever that means). After years of patience, generous politeness, and silent suffering, I can no longer tolerate such smallness among us. It's time to stop this silliness.

The claims of some egg tempera fundamentalists are very interesting and even entertaining *but they aren't true* and do not withstand the weight of historical facts. Icons have, from the earliest times, been created using a variety of media and the oldest icons are not egg tempera, they're encaustic (painted with pigments suspended in melted wax). Although some people try to make everything symbolic of something else, it isn't. Sometimes paint is just paint. I say all that blather is just cud for idle minds to chew on while looking for a diversion from contemplative silence. Or maybe all this faux controversy is a way to bolster fragile egos? In either case, it's nonsense—it makes no sense. I personally know a significant number of Orthodox iconographers who use acrylic paint, even some who use it in combination with their egg tempera. (Don't ask me how that works.)

If you're a novice iconographer who has taken one or two courses with an egg tempera painter, remember that everything you, or they, know is not everything there is to know. If you're a teacher who is passing these opinions along to your students, I ask you to ask yourself why you are saying these things. If you're honest, I hope you'll discover that it's because you really love your medium. But if it's

because you believe the fact that you use egg tempera somehow makes you superior, you might want to see your confessor to work that out.

None of this is about being right; it's about being prayerful and loving. So sisters and brothers, I suggest we call a truce and move forward together. We paint icons to help people pray so that they might be found by God. Ultimately our opinions matter very little. God and history will have the last word and it's unlikely any of us will live to know what that is. In all things, including iconography, let charity be the last and best word.

ADVENTURES WITH ACRYLIC

I recently tried an experiment based on a photograph in my copy of *Russian Icons Today*,[6] an excellent, though out-of-print, resource. In the section on the Russian master iconographer Father Xenon, there's a picture of the Virgin of Kazan. It's an unfinished panel on which Fr. Xenon has done a great deal of preliminary shadow work in a watery application of his outline color. It piqued my interest and for years I've meant to try it. So during a course I was teaching at the Pecos Benedictine Monastery in New Mexico, I decided to give myself a chance to see what I could do. First, I applied the drawing to a small panel prepared in the traditional manner with natural gesso, which is extremely porous. Next, I watered down my paint and worked in the shadows very boldly. On top of that, I applied the base colors in thin layers. At this point, the underlayer of shadows did its magic and the icon looked

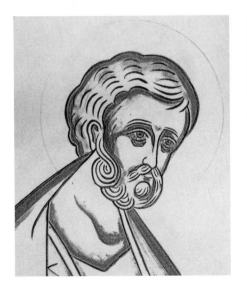

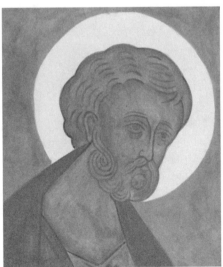

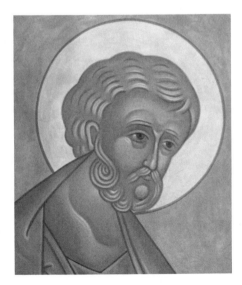

almost complete without any highlights. It was really exciting to see how easy it was to achieve this professional look so easily. After that, I applied the highlights, the finishing work of the reinstating the lines, and had a beautiful small icon that took only a couple of hours to complete. Oddly enough, it looked just like the egg tempera icons in the book but was done with my regular acrylic paints. If you'd like to try this experiment at home, get a really good panel and jump in! I think you'll be amazed.My purpose in presenting this experiment is to ask the question of whether it is the egg tempera or the high quality panels that give some icons the wonderfully rich appearance they have. My work is often mistaken for egg tempera and I really enjoy when that happens. A certain sense of glee comes over me when I can tell someone they are looking at an icon painted in acrylic. I suspect the key is the panel and thin layers of paint, not the binding agent. Obviously this is no argument against the theological criteria proposed by those who claim that only natural materials should be used in iconography. To that, all I can offer is my view that there is nothing in the universe that God, in the beginning, did not create.

— Appendix D —
Glossary of Iconography Terms

ANCIENT OF DAYS: An image of God the Father.

ANGEL: A heavenly messenger, usually portrayed with wings.

ARCHANGEL: A rank of angels including Michael, Gabriel, Raphael, etc.

ARCHEIEROPOIETOS: An image "not made by human hands," such as the face of Jesus on the cloth or the Guadalupe image of Mary.

AUREOLE: A visual reference to heaven in the form of a semicircle, circle, or elliptical shape.

BURNISH: To polish gold leaf with cotton or a special polishing tool.

CANON(S): The standards of measure or rules of iconography.

CHASUABLE/ PENULLA: A large outer garment of the Romans which was adopted by the Christians as the outer Eucharistic vestment worn by priests and bishops. Originally it was a very full garment which eventually was reduced by cutting away either the front (Byzantine) or the sides (Roman) in order to make it easier for the cleric to wear.

CHITON: Inner garment (Ispod)

CLAVIUM: The shoulder stripe on a tunic or undergarment worn in the Roman/Byzantine Empire as a sign of social status.

COPTIC: Egyptian Christianity encompassing much of North Africa as well as the term for the style of iconography peculiar to that region.

CRUCIFIX: A cross with a representation of the crucified figure of Christ on it.

DEISIS: A supplication grouping with Christ or the Mother of God at its center with saints, angels, or prophets bowing on either side.

DEMATERIALIZATION: The stylistic manner of removing the human figure from realistic representation to communicate the spiritual as well as the physical.

DIVINIZATION: The Eastern spiritual concept of God becoming human in order that we might become like God.

DOUBLE REFLECTION: A method of highlighting garments that uses a completely different color to create a special effect of radiance.

EGG TEMPRA: The painting medium created by mixing pigments with the contents of the yolk sack of an egg along with a preservative.

ENCAUSTIC: The painting medium created by mixing pigments with melted wax that was employed in many of the earliest panel icons.

ENLIVENERS: Small, light hatch lines used to create the brightest highlights on skin areas.

FORERUNNER: The title given to John the Baptist in the Eastern church.

GLAZE: A translucent layer of color, created by combining a medium with pigment, applied over an area of an icon.

GREEK: A general term for one of the major styles in iconography that includes most of the Mediterranean area.

HALO: Light emanating from a holy person, usually rendered as a circle of gold around the head.

HESYCHISM: The contemplative spirituality of the silence of God practiced by many who pray the Jesus Prayer.

HIMATION- Outer garment (Riza)

HOLY DOORS/ ROYAL DOORS: The center doors of the iconostasis through which only the priest may pass while serving the liturgy.

HOLY FACE: The image of the face of Jesus on the cloth that is known in the West as "Veronica's Veil."

ICONOCLAST: An icon breaker; someone who opposed images of the divine.

ICONODULE: One who supports the creation and use of images of the divine.

ICONOSTASIS: Literally "the place where the icons stand"; the wall of icons between the sanctuary and the nave of an Eastern church.

INVERSE PERSPECTIVE: The method of creating the illusion that objects appear larger as they move further away from the viewer of an icon.

ISPOD: The inner garment. (Chiton)

JESUS PRAYER/PRAYER OF THE HEART: An Eastern Christian mantra prayer practiced in conjunction with the breath.

LORD SABBAOTH: A representation of God the Father found in some icons that is restricted by the canons of iconography.

MAPHORION: The outer garment, a shawl-like veil, worn by women in iconography.

MITRE: The crownlike hat worn by Eastern bishops and other designated priests.

OMIPHORION/ PALLIUM: The white scarf overlaid with crosses worn by Eastern bishops or by the Pope of Rome and Roman archbishops but in a highly abbreviated form.

PROPLASMOS: Literally "first skin"; the base color for skin in iconography (see "SANKIR").

RIZA: The outer garment and/or the metal cover placed over an icon. (Himation)

RUSSIAN: A general term for one of the styles of iconography related to most of northeastern Europe.

SANKIR: The base color for skin areas (see "PROPLASMOS").

SCHEMA/GREAT SCHEMA: A hooded scapular with the symbols of Christ's passion embroidered upon it that is worn by only the holiest monastics.

SHOWER CAP: The turbanlike headgear worn by Byzantine women under the maphorion.

SIGN: One of the major types of icons of the Theotokos.

SYNAXIS: Literally "the gathering" or "assembly" of a group of figures in an icon.

TENDERNESS: One of the major types of icons of the Mother of God where the cheeks of Mary and the child Jesus are pressed together.

THEOSIS: See "DIVINIZATION."

THEOTOKOS: Literally "God bearer"; a title for Jesus' mother, Mary.

WASH: An application of diluted paint similar to water color in consistency.

WONDER WORKING: A title given to icons credited with miraculous occurrences such as healings and conversions, or which weep myrrh.

— APPENDIX E —
Selected Resources

Alpatov, M.V. *Early Russian Icon Painting*. Moscow: Iskusstvo, 1978.

Berrigan, Daniel. *The Bride: Images of the Church*. Maryknoll, NY: Orbis Books, 2000. (ISBN 1-57075-305-9)

Brenske, Helmut, Stefan Brenske, and Paul Maslow. *Ikonen selber malen: Von der Vorlage bis zur fertigen Ikonen*. Augsburg, Agustus Verlag, 1980. (ISBN 3-8043-2721-9)

Chittister, Joan. *The Friendship of Women: A Spiritual Tradition*. Franklin, WI: Sheed & Ward, 2000. (ISBN 1-890890-10-3)

Collins, Gregory. *The Glenstal Book of Icons: Praying with the Glenstal Icons*. Blackrock, Ireland: Columba Press, 2002. (ISBN 1-85607-362-9)

de Vyver, Jane Merriam. *The Artistic Unity of the Russian Orthodox Church: Religion, Liturgy, Icons and Architecture*. Belleville, MI: Firebird Publishers, 1992. (ISBN 1-881211-01-0)

Evseyeva, Lilia, Natalia Komashko, Luka Golovkov, Elena Ostashenko, Olga Popova, Engelina Smirnova, Eanna Yakovleva, and Eirina Yazykova. *A History of Icon Painting*. Translated by Kate Cook. Moscow: "Grand-Holding" Publishers, 2005. (ISBN 5-7235-03-05-7)

Forest, Jim. *Praying with Icons*. Maryknoll, NY: Orbis Books, 1997. (ISBN 1-57075-112-9)

Girogi, Rosa. *Saints in Art*. Translated by Thomas Michael Hartmann. Los Angeles, CA: J. Paul Getty Trust, 2003. (ISBN 0-89236-717-2)

Hart, Russell. *Communing With the Saints*. Springfield, IL: Templegate Publishers, 1994. (ISBN 0-87243-203-3)

Heldman, Marilyn, and Stuart C. Munro-Hay. *African Zion: The Sacred Art of Ethiopia*. New Haven and London: Yale University Press, 1993. (ISBN 0-300-05819-5 and ISBN 0-300-05915-9)

Jazykova, Irina. *Io Faccio Nouva Ogni Cosa: L'icona nex XX secolo*. Milano, Italy: Casa De Matriona, 2002. (ISBN 88-8720-38-8)

Juzj, Maria Giovanna. *Transfiguration: Introduction to the Contemplation of Icons*. Boston, MA: St. Paul Books & Media, 1991. (ISBN 0-8198-7350-0)

Kostsova, A. *The Subjects of Early Russian Icons*. St. Petersburg: Iskusstvo Publishers, 1994.

Kuteynikova, N. S., ed. *Modern Orthodox Icon*. Saint Petersburg: Znaki Publications, 2007. (ISBN 5-93113-008-X)

Lasarev, V. N. *The Double-Faced Tablets from the St. Sophia Cathedral in Novgorod: Pages from the History of Novgorodian Painting.* Moscow: Iskusstvo Art Publishers, 1973.

Likhachov, Dimtry, Vera Lavrina, and Vasily Pushkariov. *Novgorod Icons: 12–17th Centuries.* Leningrad: Aurora Art Publishers, 1980, 1983.

Lombardo, Giuseppe. *L'icona: Manuale di iconografia bizantina.* Siracusa, Italy: "Istina" Siracusa, 2005. (ISBN 88-86606-43-5)

Lowden, John. *Early Christian & Byzantine Art.* New York: Phaidon Press, 1997. (ISBN 0-7148-3168-9)

Markelov, Gleb. *Russian Icon Designs: A Compendium of 500 Canonical Imprints and Transfers of the Fifteenth to Nineteenth Centuries.* 2 vols. St. Petersburg: Ivan Limbakh Publishing House, 2001. (ISBN 5-89059-004-9)

Martin, Linette. *Sacred Doorways: A Beginner's Guide to Icons.* Brewster, MA: Paraclete Press, 2002. (ISBN 1-55725-307-2)

Maxym, Lucy, ed. *The History and Art of the Russian Icon from the X to the XX Centuries.* Farmingdale, NY: Frank C. Toole & Sons, 1986. (ISBN 0-940202-06-9)

McKenna, Megan. *Mary, Mother of All Nations.* Maryknoll, NY: Orbis Books, 2000. (ISBN 1-57075-325-3)

Museum of Russian Icons. *Two Museums/One Culture: A Cooperative International Exhibition of Russian Icons from the Collection of the Sate Tretyakov Gallery and Museum of Russian Icons.* Clinton, MA: Museum of Russian Icons, 2008.

Nelson, Robert S., and Kristin M. Collins, eds. *Holy Image, Hallowed Ground: Icons from Sinai.* Los Angeles, CA: J. Paul Getty Trust, 2006. (ISBN 978-0-89236-856-3)

Nes, Solrunn. *The Mystical Language of Icons.* London: St. Paul's Publishing, 2000. (ISBN 085439-584-9)

Nicolaeva, Anna, ed. *Contemporary Icon Painting- Moscow.* Moscow: Cameran 2006. (ISBN 5-88149-256-0

Nowen, Henri J. M. *Behold the Beauty of the Lord: Praying with Icons.* Notre Dame, IN: Ave Maria Press, 1987. (ISBN 0-87793-356-1)

Onasch, Konrad, and Annemarie Schneiper., *Icons: The Fascination and the Reality.* Translated by Daniel Conklin. New York: Riverside Book Company, 1997. (ISBN 1-878351-53-2)

Ouspensky, Leonid, and Vladimir Lossky. *The Message of Icons.* Crestwood, NY: St. Vladimir's Seminary Press, 1983. (ISBN 0-913836-77-X and ISBN 0-913836-99-0)

Paloumpis Hallick, Mary. *The Story of Icon.* Brookline, MA: Holy Cross Orthodox Press, 2001. (ISBN 1-885652-42-9)

Popova, Ol'ga, Engelina Smirnova, and Paola Cortesi. *Les icons: L'historie, les styles, les themes, du vi siecle a nous jours.* Paris: Editions Solar, 1996. (ISBN 2-263-03349-1)

Proud, Linda. *Icons: A Sacred Art.* Norwich, UK: Pitkin Guides 2002. (ISBN 0-85372-990-5)

Puhalo, Archbishop Lazar. *The Ikon as Scripture and Ikons of the Last Judgment.* Dewdney, British Columbia, Synaxis Press, 1972. (ISBN 919-67245-0)

Quenot, Michael. *The Resurrection and the Icon.* Crestwood, NY: St. Vladimir's Seminary Press, 1997. (ISBN 0-88141-149-3)

Saint Theodore the Studite. *On the Holy Icons.* Translated by Catharine Roth. Crestwood, NY: St. Vladimir's Seminary Press, 1981. (ISBN 0-913836-76-1)

Sendler, Egon. *The Icon: Image of the Invisible.* Redondo Beach, CA: Oakwood Publications, 1998. (ISBN 0-9618545-0-2 and ISBN 0-9618545-1-0)

Talbot-Rice, T. *Icons.* Secaucus, NJ: Wellfleet Press, 1990. (ISBN 1-55521-632-3)

Taylor, John. *Icon Painting.* New York: Mayflower Books, 1979. (ISBN 0-8317-4813-3 and ISBN 0-8317-4814-1) I really don't know except that sometimes the hard cover and soft cover books have two????

Timchenko, S. V. *Russian Icons Today.* Moscow: Sovremennik, 1994. (ISBN 5-270-01477-7)

Tradigo, Alfredo. *Icons and Saints of the Eastern Orthodox Church.* Translated by Stephen Sartarelli. Los Angeles, CA:Ghetty Publications 2006. (ISBN 10: 0-89236-845-4)

Tregubov, Andrew. *The Light of Christ: Iconography of Gregory Kroug.* Crestwood, NY: St. Vladimir's Press, 1990.

Weitzman, Kurt, Gainne Alibegasvili, Aneli Volskaja, Manolis Chatzidakis, Gordana Babic, Mihail Alpatov, and Teodora Voinescu. *The Icon.* New York: Alfred A. Knopf, 1982.

Weitzman, Kurt, Manolis Chatzidakis, and Sventozar Radojcic. *Icons.* New York: Alpine Fine Arts Collection, undated. (ISBN 0-9333516-07-X)

Zaczek, Iain. *The Art of the Icon.* London: Studio Edition, 1994. (ISBN 1-85891-178-8)

Zibawi, Mahooud. *The Icon: It's Meaning and History.* Collegeville, MN: Liturgical Press, 1993. (ISBN 0-8146-2264-X)

INTERNET RESOURCES

You can find lots of information by searching the internet for words like "religious icon," "iconography," "Byzantine icon," "Russian icon," or "iconographer." Remember that the word "icon" is everywhere these days and being specific will enhance your results. This is a random sampling of materials I have found on the web recently. Some of it is highly instructional and others are simply good resources that you may find interesting.

- http://ad-orientem.blogspot.com/2006/09/western-saints-icon-project.html (More Western Saints)
- http://aggreen.net/iconography/icons.html (An Extensive Index of Sources)
- http://www.aidanharticons.com/western_orthodox_saints.html (Aidan Hart, Iconographer)

- http://www.allmercifulsavior.com/icons/Western.html (Western Saints Icons)
- http://www.atelier-st-andre.net/en/index.html (Atelier Saint-André Studio)
- http://www.bai.org.uk/IanKnowles.asp?Title=Members%60%20Pages (British Association of Iconographers)
- http://www.betsyporter.com/patterns.html (Drawings)
- http://www.byzantineiconography.gr/en/bio.asp (Dimitrios Mourlas, Iconographer)
- http://www.byzantinesacredart.com/index.html (Byzantine Sacred Art)
- http://www.comeandseeicons.com/papas.htm (Nick Papas, Iconographer)
- http://www.comeandseeicons.com/zimmerman.htm (Phil Zimmerman, Iconographer)
- http://www.endersisland.com/institute-of-sacred-art (St. Michael Institute of Sacred Art)
- http://www.gsinai.com/rw/icons/icon_workshop.php (Saint Gregory of Sinai Monastery— Icon Workshop)
- http://www.gsinai.com/rw/icons/icons/painting_a_face.php (Saint Gregory of Sinai— Painting a Face)
- http://www.hexaemeron.org/index.htm (Hexameron Iconographers)
- http://www.holytrinitydc.org/ParishLife/Groups/Icon/index.htm (Holy Trinity Iconographers Guild, Washington, DC])
- http://www.iconinstitute.org/links.html (Links to Oregon Iconographers)
- http://www.iconenatelierverdonk.nl/index-english.html (Jan Verdonk, Iconographer)
- http://www.iconofile.com/default.asp?page=main&session_id= (Iconofile)
- http://www.iconography.ro/documentation.html (Romanian Icon Site)
- http://icon-painting.blogspot.com/ (Iconography Blog)
- http://www.iconsexplained.com/iec/iec_masters.htm (General Information)
- http://www.ikonerin.org/index.html (Irish Iconographer's Guild)
- http://www.ikonograph.com/ikonograph/Welcom.html (Valentino Icon Studio)
- http://www.izograph.com/ (Xenia Pokrovsky)
- http://jcoleicons.com/Site/Home.html (Jody Cole, Iconographer)
- http://www.liturgica.com/html/Icon.jsp (General Information)
- http://www.liturgy.ru/~philip/index.html (General Information—Russian)
- http://nesusvet.narod.ru/ico/icons/cat_pr.htm (Russian Icon Drawings)
- http://www.newguildstudio.com/icon.htm (New Guild Iconographers)

- http://www.newskete.com/ (Communities of New Skete) step of Theotokos)
- http://www.pecosmonastery.org/IconSchoolSchedule.htm (Pecos Iconography School)
- http://www.psta.org.uk/index.php?n=Education.IconPainting (The Prince's School of Traditional Arts)
- http://www.raaad.org/prosoponschool.org/new/journal.html (Prosopon School)
- http://www.rollins.edu/Foreign_Lang/Russian/frame1.html (Comprehensive site)
- http://www.rusicon.ru/eng/sci/secrets/ (Russian step-by-step of Christ)
- http://www.rusicon.ru/eng/sci/secrets/godmother.htm (Russian step-by-step of Theotokos)
- http://www.seraphicrestorations.com/ (Marek Czarnecki, Iconographer)
- http://www.shkolnikstudio.com/ (Dmitry Shkolnik, Iconographer)
- http://www.skete.com/ (Saint Isaac of Syria Monastery)
- http://www.thehtm.org/catalog (Holy Transfiguration Monastery, Brookline, MA)
- http://transformationscenter.org/programs/icon-W08.htm (Diane Hamel, Iconographer)
- http://waynehajos.com (Wayne Hajos, Iconographer)]
- http://www.youtube.com/watch?v=S-eYGXAg-ek&feature=related (Icon)
- http://www.youtube.com/watch?v=XfOHUkfF154&feature=related (Byzantine Icons)
- http://www.youtube.com/watch?v=Ew7uZjSdrUk&feature=related (Drawing Icons, Part 1)
- http://www.youtube.com/watch?v=B75KeQ_Yl2E&feature=related (Drawing Icons, Part 2)
- http://www.youtube.com/watch?v=-Rkkg5o1x6c&feature=related (Drawing Icons, Part 3)
- http://www.youtube.com/watch?v=-qvW209MTW1k (Greek Hagiography)
- http://www.youtube.com/watch?v=fDlUCVIYI4E&feature=related (Fast Painting, Christ's Face)
- http://www.youtube.com/watch?v=V_1JP41cp1g (Monastery Icons)
- http://www.youtube.com/watch?v=37HbZ6w0W7Q&feature=related (La Dame des Icônes)
- http://www.youtube.com/watch?v=2oePDxd3PBw&feature=related (Greek Orthodox: Writing Icons)
- http://www.youtube.com/watch?v=wiuN7_nqR7g (Sommarkurs)
- http://www.youtube.com/watch?v=YKQ5bulEQbs&feature=related (Icons of Sister Magnificat Trailer)
- http://www.youtube.com/watch?v=R319A0z6ZLA (Museum of Russian Icons)
- http://www.elizabeththewonderworkerstudio.com (Kathy Sievers, iconographer)

— ICON PATTERNS —

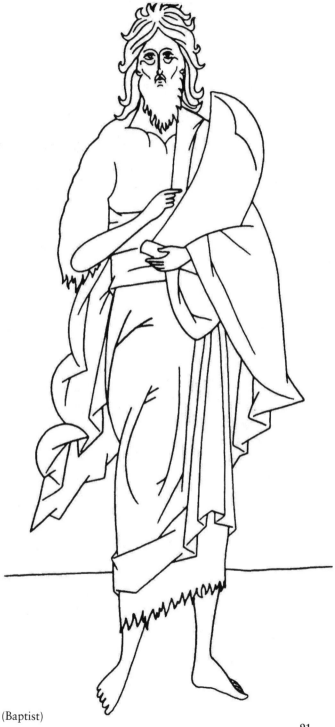

Most iconographers collect drawings (a.k.a. cartoons or patterns) from which they can create their own icons. These drawings are the work of several contemporary icon painters and based upon older prototypes. Please feel free to use them but know that you will have to do the research to figure out your colors, the details, and the step-by-step process you should follow. It can be based upon the materials provided in this book as well as in *A Brush with God*. With this drawing and the information you have gathered you should be able to create a fine icon.

Saint John the Forerunner (Baptist)
(Peter Pearson)

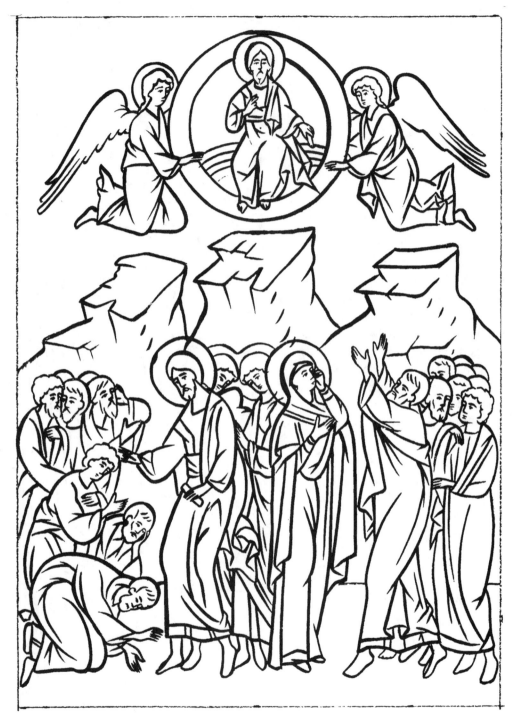

The Ascension
(Peter Pearson)

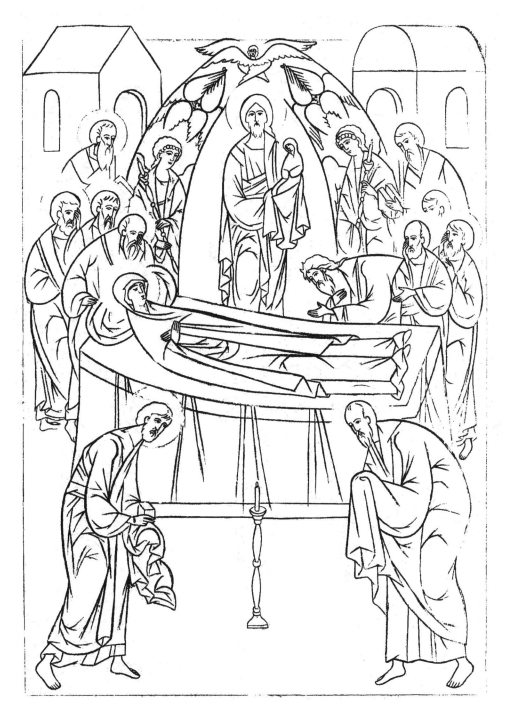

The Dormition
(Peter Pearson)

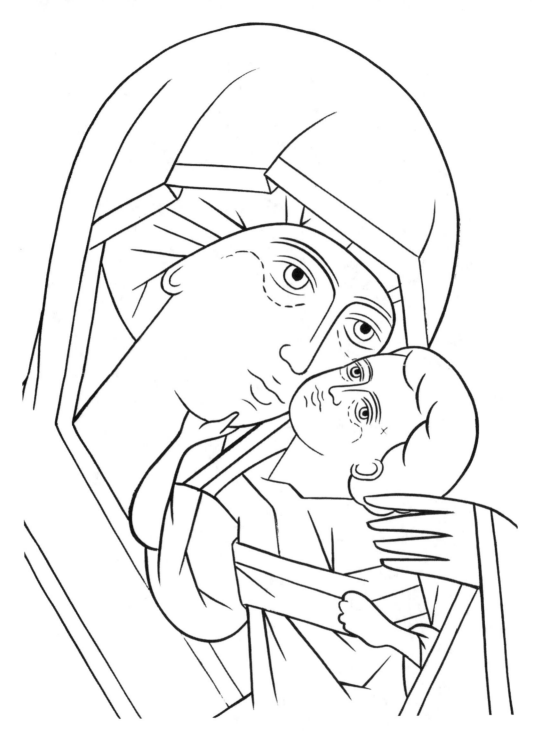

Mother of God of Peace
(Peter Pearson)

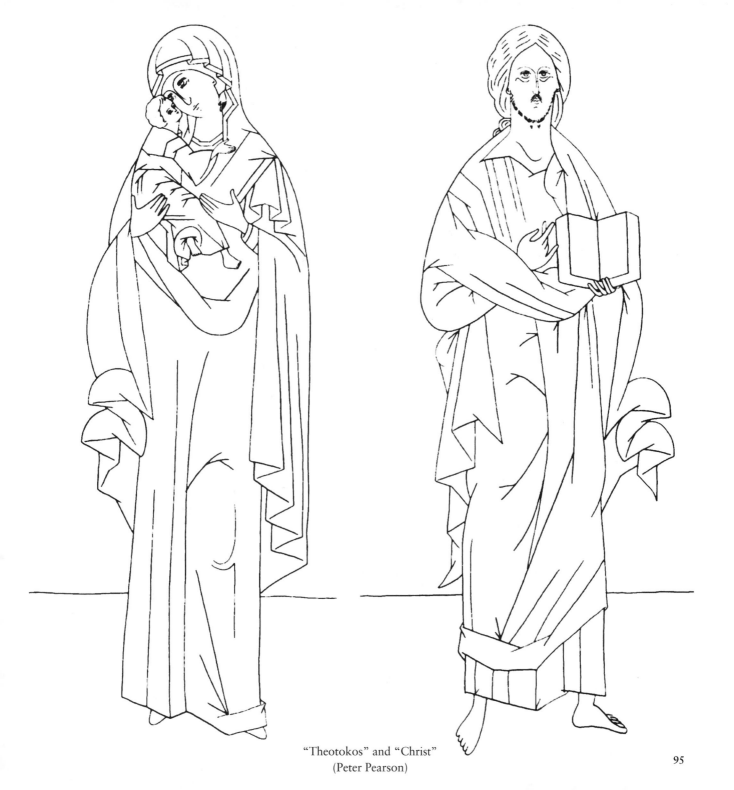

"Theotokos" and "Christ"
(Peter Pearson)

95

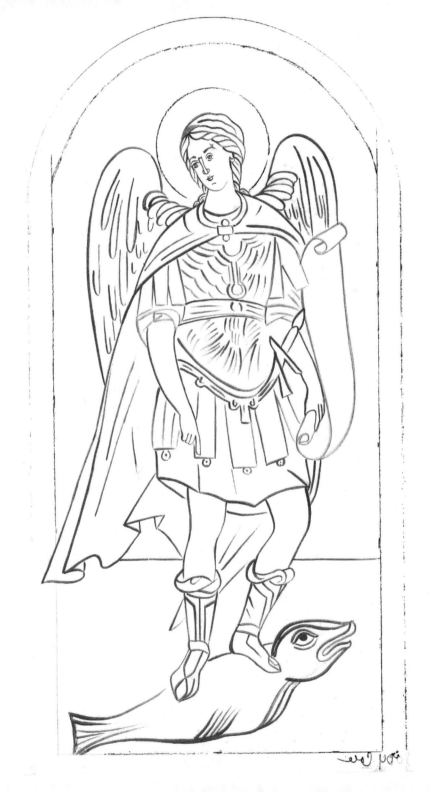

Archangel Raphael
(Judy Cole)

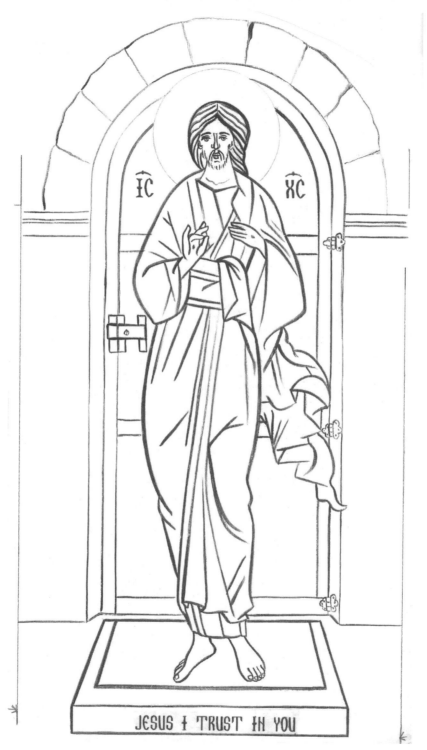

JESUS ✝ TRUST IN YOU

Christ, Divine Mercy
(Jody Cole)

97

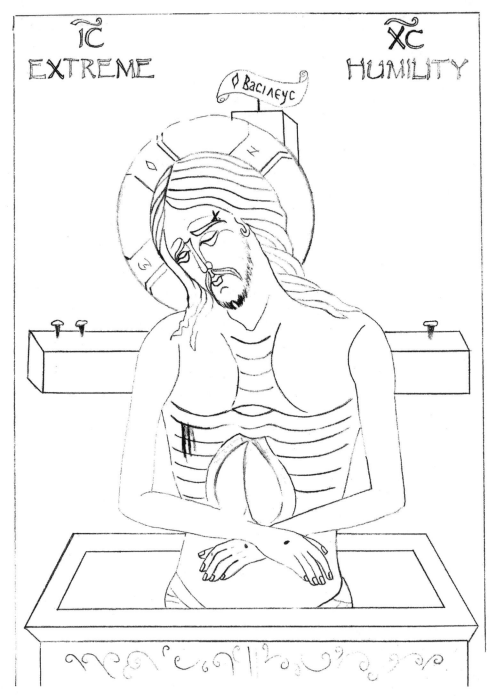

after Creton - End of 16TH Cent. Variant of Early Byn. Man of Sorrow

Extreme Humility

(Jody Cole)

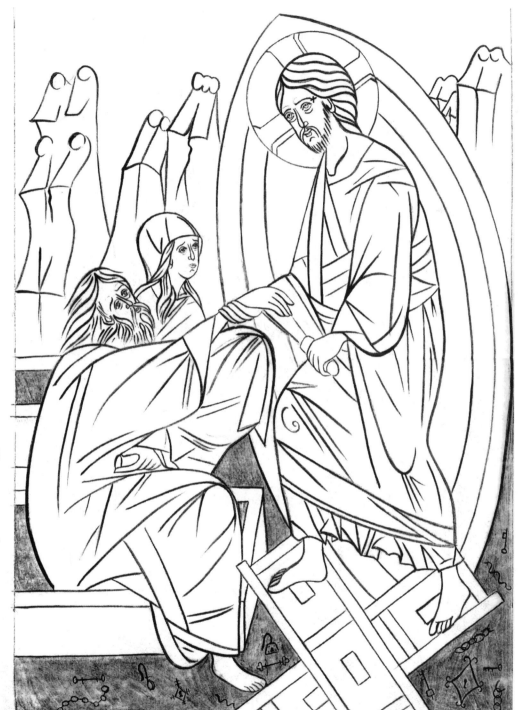

Anastasis
(Jody Cole)

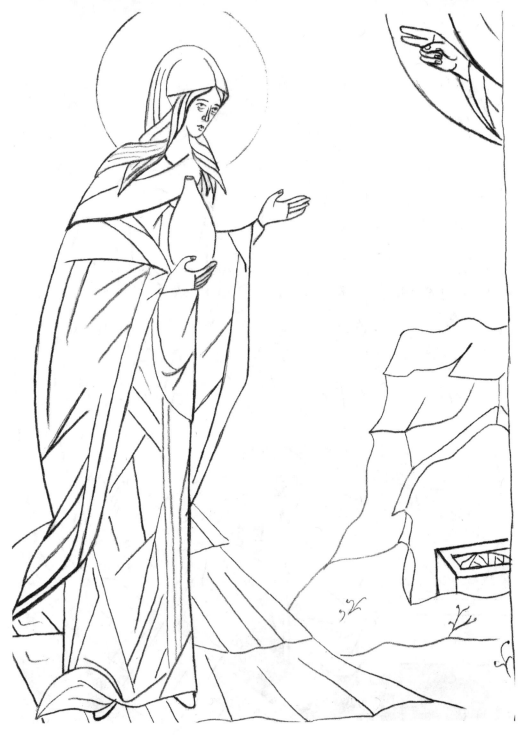

St. Mary Magdalene
(Jody Cole)

St. Francis
(Jody Cole)

Angel with the Golden Hair
(Father Damian Higgins)

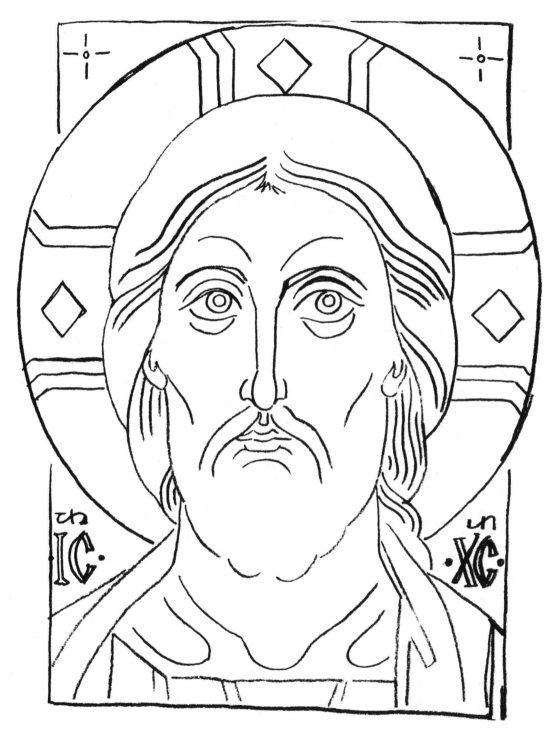

The Savior
(Father Damian Higgins)

103

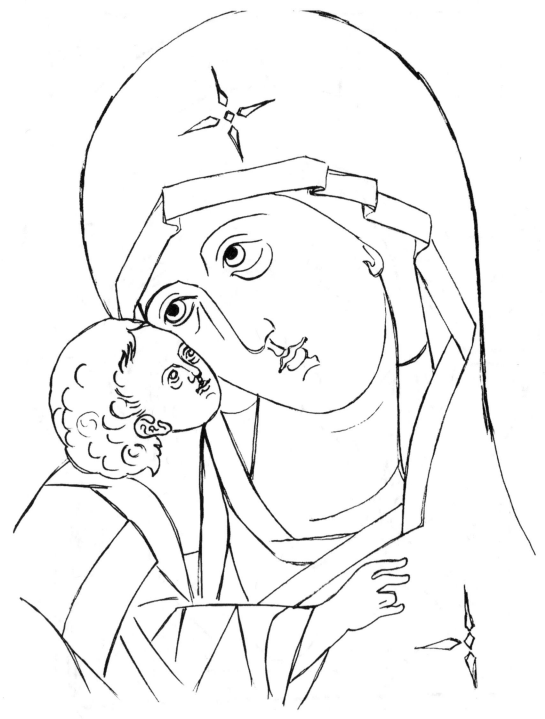

Tenderness Mother of God
(Father Damian Higgins)

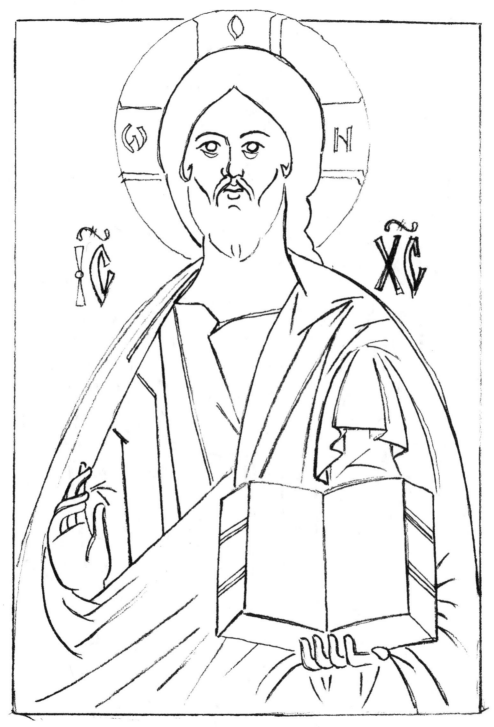

Christ the Teacher
(Father Damian Higgins)

105

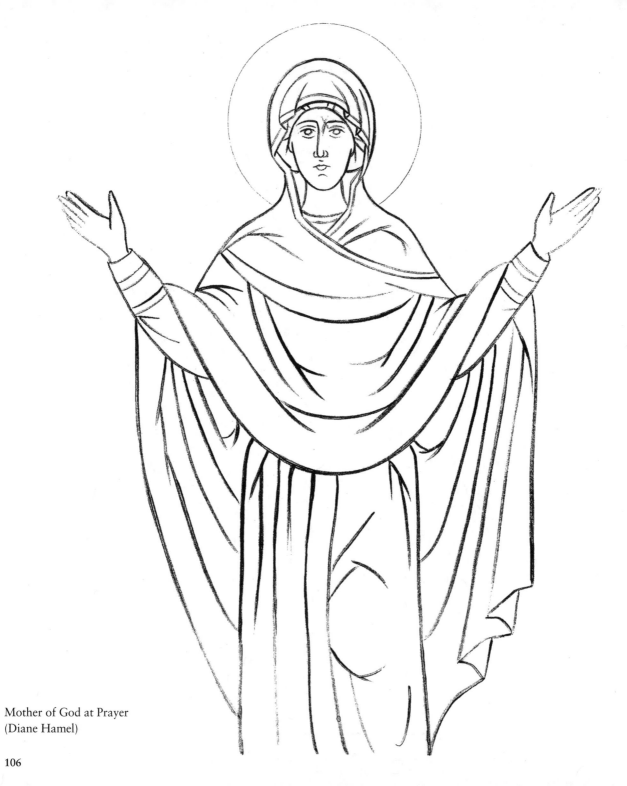

Mother of God at Prayer
(Diane Hamel)

106

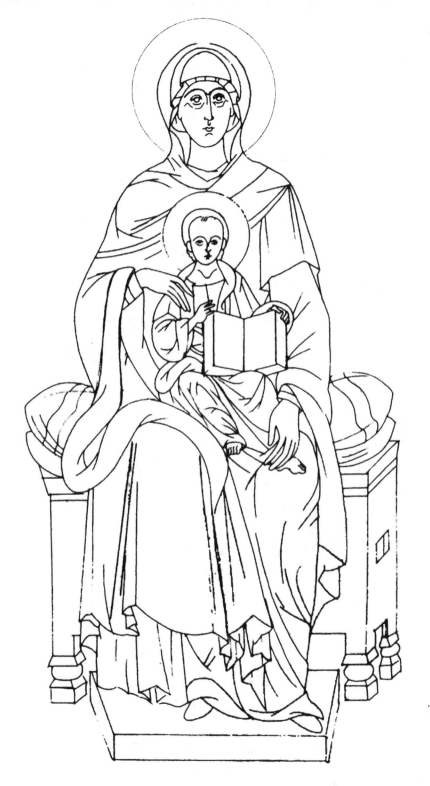

Theotokos Enthroned
(Diane Hamel)

107

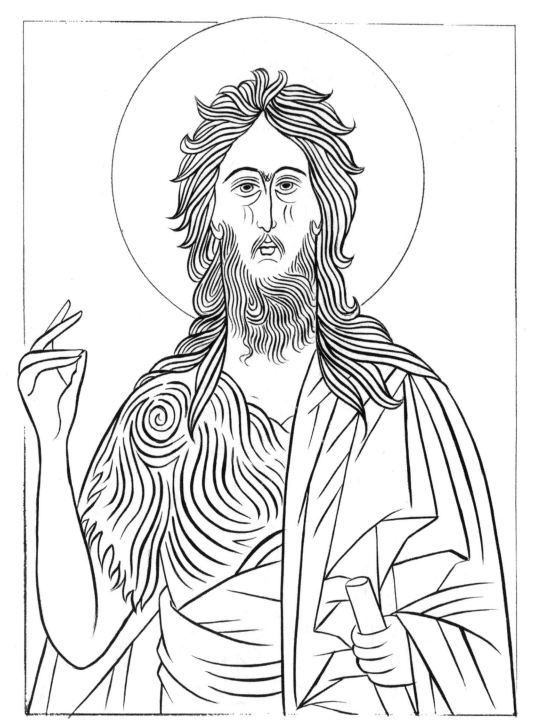

St. John the Forerunner (Baptist)
(Jody Cole)

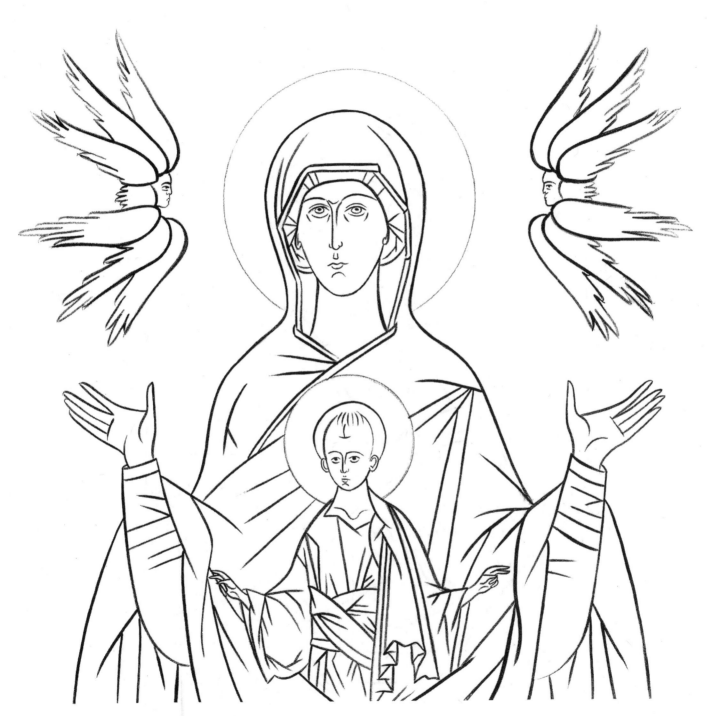

Virgin of the Sign
(Diane Hamel)

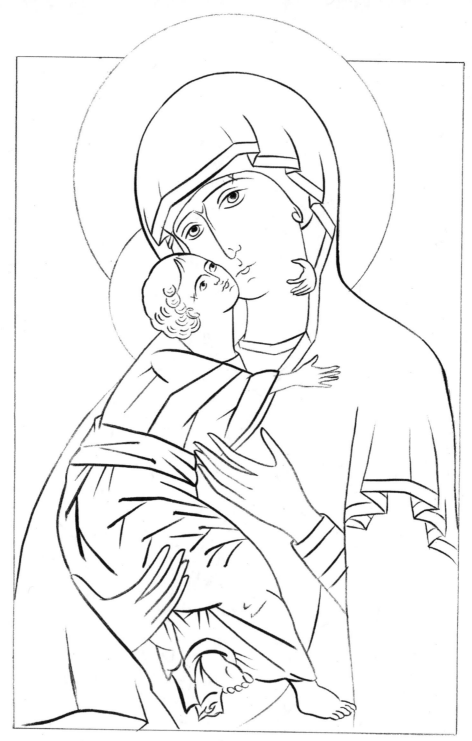

Vladimir Mother of God
(Diane Hamel)

Anastasis
(Wayne Hajos)

Saint Therese of the Child Jesus and the Holy Face (Lisieux)
(Charles Lucas)

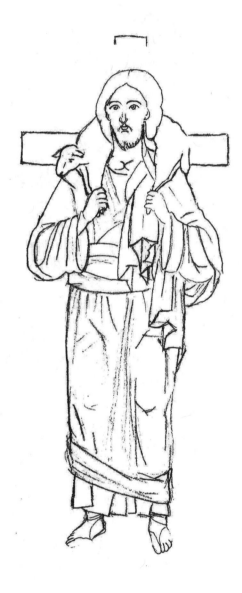

Christ the Good Shepherd
(Wayne Hajos)

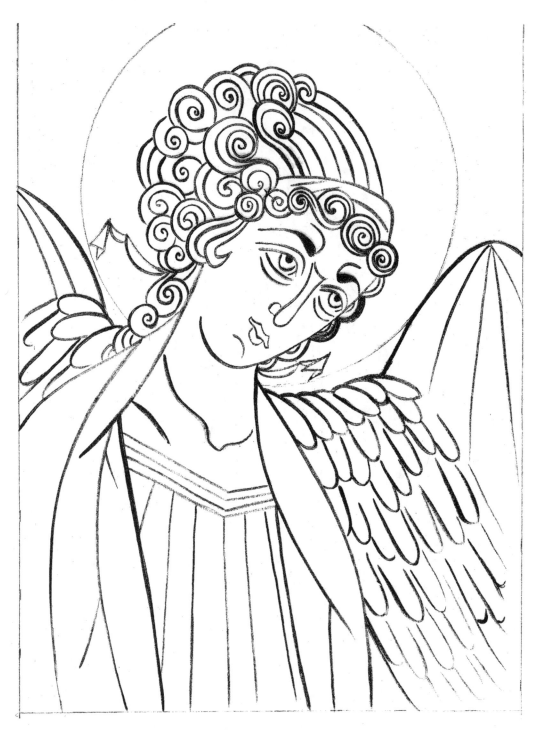

Guardian Angel
(Jody Cole)

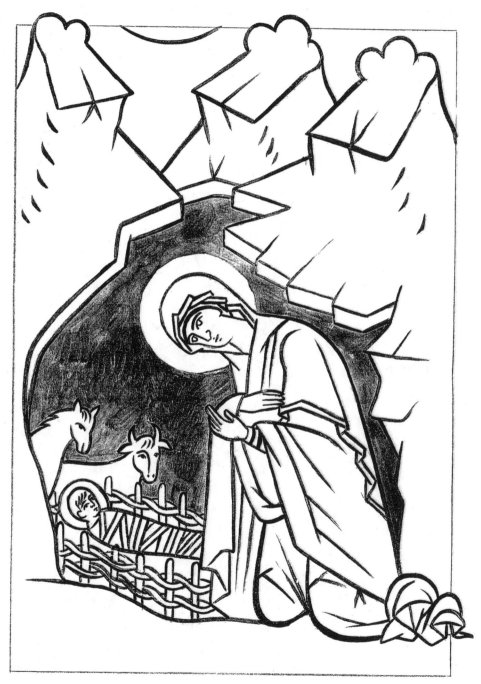

Nativity
(Peter Pearson)

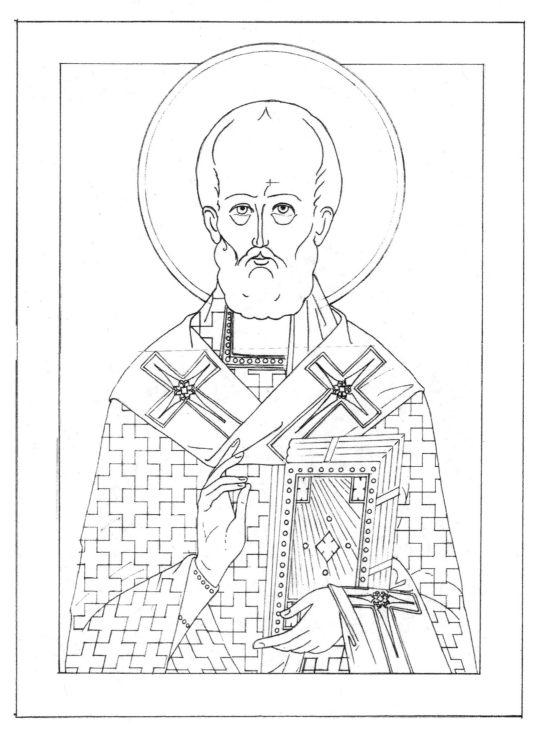

St. Nicholas
(Charles Lucas)

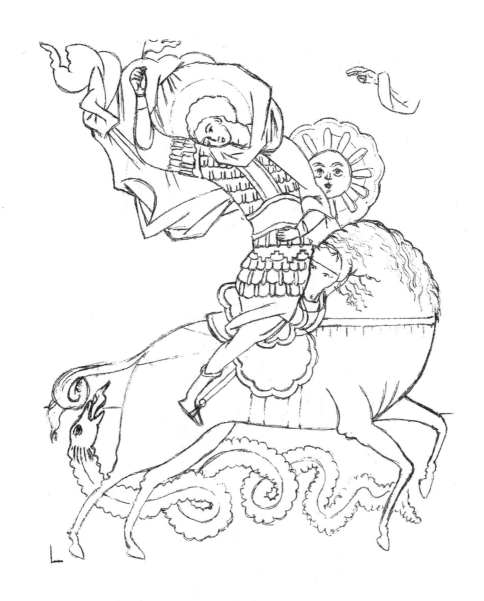

Saint George and the Dragon
(Wayne Hajos)

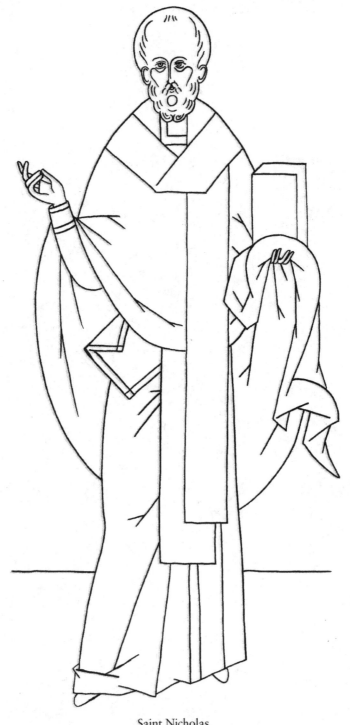

Saint Nicholas
(Peter Pearson)

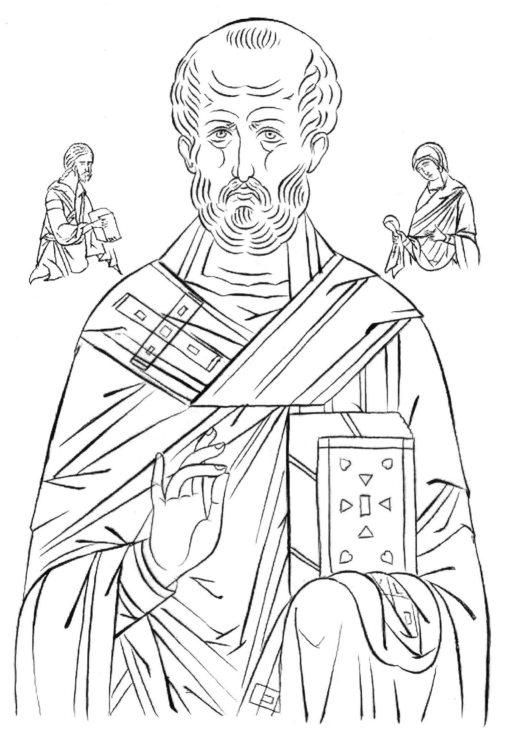

St. Nicholas
(Marek Czarnecki)

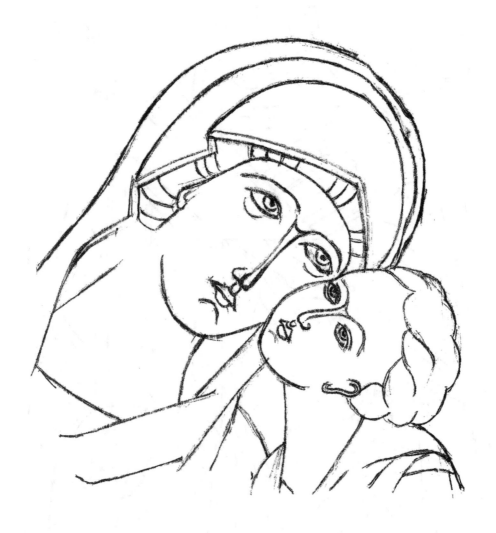

Tenderness Mother of God
(Wayne Hajos)

Tenderness Mother of God
(Peter Pearson)

COMMISSIONING AN ICON

The original icons I create are produced through the ancient processes and canons of traditional iconography using modern materials such as acrylic paints and gold leaf on cabinet-quality birch plywood or on more expensive, handcrafted panels of solid bass wood with oak spines. There's no catalog of icons that are available since most of this work is created in response to a specific request, but you can visit my website and look at the images provided in the gallery there to assist you. These are updated regularly. If you have a specific image in mind, providing a copy would make the process simpler. At the same time, I have some smaller icons in my studio that are already available; the subjects and prices of these can be discussed if you would contact me. I'm unable to offer prints at this time.

Icons are normally painted on wooden panels. These are usually rectangular, the dimensions of which are based upon ancient mathematical concepts of perfection. Other shapes and sizes are available, as are panels with raised borders. At times, icons can also be painted on canvas that can be adhered to wall surfaces simulating the look of fresco without the cost of lengthy rentals of scaffolding. Obviously, the more complex the materials and preparation, the higher the price, but since this is a vocation rather than a scheme to make money, my prices are very reasonable in comparison to more commercial ventures. Prices for an icon usually start at about $350 for a simple composition on a 9 x 12 inch panel. Shipping, delivery, packing, insurance, and taxes are not included. The specifics can be discussed and prices are offered on a case-by-case basis. My backlog of work extends to about one year. If you have an urgent request, an additional fee will apply. I will be as clear as possible about the deadlines and what I'm able to do.

On larger jobs, I'm able to create sketches, do research, and make presentations. Since the labor can be extensive, I will ask for a retainer that can be applied to the final cost should you decide to proceed with the project. Keep in mind that I am an iconographer, not an architect or an interior designer. Iconography has clear limits. I will do as much as possible to facilitate your needs so long as it does not seriously compromise the canons of traditional iconography.

To meet the demands of those who seek me out, I sometimes enlist the help of some of my best students in creating the requested icons. Doing this ensures that the icons can be created within a reasonable amount of time and at a reasonable cost. In every instance I have oversight of the process and guarantee the quality of the work. Rest assured that you'll be pleased with the outcome.

If you have any questions, please don't hesitate to contact me.

Contact Information

Peter Pearson

pearson@nb.net
website: www.nb.net/~pearson

About the Author

Peter Pearson has studied iconography for over forty years. Self-taught for fifteen years, in 1984 he studied under Russian iconographer Dr. Nina Bouroff in Bethesda, Maryland. After entering a Benedictine monastery in 1991, Peter worked and studied with Philip Zimmerman at the Saint John of Damascus Academy of Sacred Arts, an Orthodox school of icon painting in Ligonier, Pennsylvania, where he assisted in several projects and classes. In 1994, he studied with Nicholas Papas in Greensburg, Pennsylvania, and in 1997 he attended the Iconography Institute at Mount Angel Abbey in Oregon, where he studied with Charles Rohrbacher of Juneau, Alaska. On several of his trips to the Northwest, he worked with some iconographers from that area and learned about their techniques. Peter has studied with Valentin Streltsov of Toronto, Ontario, and in 2008, he worked with Xenia Pokrovsky of the Hexameron School of Icon Painting at Saint Tikhon's Orthodox Monastery in South Canaan, Pennsylvania. Most recently, he studied with Father Damian Higgins at the Basilian Spirituality Center run by the Sisters of Saint Basil in Fox Chase, Pennsylvania.

Peter has created hundreds of icons for private collectors, churches, and other institutions throughout the world. He has made presentations on iconography to a wide variety of groups, including elementary school children, college classes, art leagues, seminarians, and senior citizen groups. Peter offers courses, workshops, and retreats throughout the United States, focusing on the technical skills involved in icon painting, as well as the spirituality of creating an icon. He and Jody Cole, one of his long-time students, have led several groups to Italy, Greece, and Turkey to study icons first-hand. In 2009 they will take a group to connect with the iconographers in Ireland. Peter's passion for this art is obvious and highly engaging.

In addition to iconography, Peter studied architectural drafting and color at the International Institute of Design in Washington, DC, and theology, with an emphasis on liturgical studies, at Saint Pius X Seminary/University of Scranton, Saint John's School of Theology in Boston, Georgetown University, and at Saint Vincent Seminary in Latrobe, Pennsylvania, where he graduated magna cum laude, completing a Master of Divinity degree in 1995. His coursework included specialized studies on the history of church architecture and liturgical vesture, the role of art in worship, as well as a full year on liturgical consultation. More recently he completed a course entitled, "The Jesus Prayer and East-

ern Christian Spiritual Practice," at the General Theological Seminary in New York City and another on the "Emergent Church" in the Diocese of Pennsylvania.

Peter is a member of the Association of Consultants for Liturgical Space and has worked on many projects as a liturgical artist and consultant, designing worship spaces, furnishings, vesture, and seasonal decorations. In every aspect of his work, Peter seeks to combine sound liturgical practice with quality artistic design. He is a priest of the Diocese of Bethlehem who presently serves as the pastor of a small parish in New Hope, Pennsylvania and is a member of the Community of Solitude, an ecumenical monastic community which lives out its vocation in the spirit of the Camaldolese Benedictines. He continues to teach, paint, and write in addition to his pastoral duties, which makes for a very full life.

Selected Major Works

All Saints Episcopal Church, Kitty Hawk, SC: Mother of God with Saints

Archdiocese of Baltimore, Cardinal's Office: Icon for the July 2000 international meeting between the Orthodox and Catholic Churches in Emmetsburg, MD

Archdiocese of Detriot, CA, Bishop's Private Chapel: Crowning of the Blessed Virgin Mary with Deisis of Selected Saints

Bishop White Seminary, Spokane, WA: Saint John Vianney

East Liberty Presbyterian Church (Taize Community), Pittsburgh, PA: Coptic Icon of Christ and Abba Menas

Fatima Retreat Center, Dalton, PA: Mother of God of Tenderness

Grace Episcopal Church, Allentown, PA: Vladimir Mother of God

Grace Episcopal Church, Mount Washington, Pittsburgh, PA: Entombment with Saints Mary Magdalene and Joseph of Arimathea; Mother of God with Archangels Michael and Gabriel; Crucifix; altarpiece; and other selected icons

Green Mountain Monastery, North Chittendon, VT: Christ the Teacher

Holy Ghost Parish, Vinita, OK: Saints Paul, William, Louis, and Francis

Holy Rosary Parish, Edmunds, WA: Festal and Deisis icons

Immaculate Conception Parish, Colville, ID: Resurrection, Christ Enthroned, and Crucifix

Marmion Abbey, Chicago, IL: Saint Joseph with Scenes from His Life

Newark Abbey, Newark, NJ: Presentation of the Mother of God

New Melleray Trappist Abbey, Peosta, IA: Holy Trinity

Prince of Peace Parish, Edgewood, MD: Smolensk Mother of God

Queen of Peace Parish, Salem, OR: The Holy Trinity

Queen of Peace Parish, Issaquah, WA: Crucifix and Holy Trinity

Redeemer Lutheran Church, Bettendorf, IA: Mother of God of Tenderness and Myrrh-bearing Women at the Tomb

Sacred Heart Parish, Evart, MI: Mother of God Pointing the Way

Saint Anne's Parish, Mackinac Island, MI: Vladimir Mother of God

Saint Augustine Church, Spokane, WA: Detail from Transfiguration

Saint Benedict's Monastery, Madison, WI: Christ Enthroned and The Hospitality of Abraham and Sarah

Saint Bernard's Parish, Mount Lebanon (Pittsburgh), PA: Replaced nine damaged wall panels

Saint Catherine's Parish, Moscow, PA: Mother of God of Tenderness

Saint Charles Borromeo Parish, Skillman, NJ: Deisis (thirteen panels)

Saint John's Abbey, Collegeville, MN: Emmaus Icon with Saints Benedict and John, Saint Leo the Great

Saint John the Baptist Byzantine Catholic Parish, Hazelton, PA: Iconostasis (over forty icons of various sizes)

Saint Joseph's Parish, Hyattsville, MD: Altarpiece (Crucifixion, Nativity, Washing of the Feet, Resurrection, Emmaus), Stations of the Cross, and devotional icons

Saint Joseph's Parish, Vancouver, WA: Mystical Supper, Pentecost, Nativity, and Resurrection

Saint Luke's Parish, Stroudsburg, PA: Saint Luke

Saint Martin de Porres Parish, McKeesport, PA : Saint Martin de Porres

Saint Mary's Abbey, Norristown, NJ: Saint Catherine of Siena, Saint Joseph, Christ the Teacher, Mother of God of Tenderness, Saints Peter and Paul, Saints Benedict and Scholastica, and a Nativity

Saint Norbert's Abbey, Paoli, PA: Mother of God of the Sign with Saints Augustine and Norbert, Crucifix, and a Christ with Saints

Saint Paul the Apostle Episcopal Church, Savannah, GA: Holy Wisdom with Theotokos and Saint John

Saint Peter's Parish, Galveston, TX: Saint Peter

Saint Peter in Chains Cathedral, Cincinnati, OH: Elijah in the Desert

Saint Philip's Episcopal Church, New Hope, PA: Saint Philip

Saint Stanislaus Parish, Summit Hill, PA: Saint Stanislaus and Christ Enthroned

Saint Thomas Episcopal Church, Oakmont, PA: Saint Nicholas

Saint Vincent's Archabbey, Latrobe, PA: Saints Benedict and Scholastica

Santa Maria del la Vid Priory, Albuquerque, NM: Pentecost Icon and Saint John the Forerunner

Teresian House Nursing Home, Albany, NY: Archangels Gabriel and Michael

Theological College, Washington, DC: Processional Cross, The Holy Trinity, Saints Teresa of Avila, Therese of Liseux, and Theresa Benedicta, Saint Augustine, Saints James, Humberto, Joseph, and the Prophet Daniel

Trinity Episcopal Cathedral, Pittsburgh, PA: Christ Enthroned

Major Exhibits

Pecos Benedictine Abbey, Pecos, NM

Rosemont College, Philadelphia, PA

Saint Norbert's Abbey, Paoli, PA

Sandscrest Retreat Center, Wheeling, WV

Washington Theological Union, Washington, DC

NOTES

1. *The Proper for the Lesser Feasts and Fasts together with The Fixed Holy Days* 3rd ed. The Church Hymnal Corporation, New York, 1980, 89.

2. Lilia Evseyeva, Natalia Komashko, Luka Golovkov, Elena Ostashenko, Olga Popova, Engelina Smirnova, Eanna Yakovleva, and Eirina Yazykova. *A History of Icon Painting*, trans. Kate Cook (Moscow: "Grand-Holding" Publishers, 2002), 132.

3. John Michael Talbot, "Canticle of Peter." From "Come to the Quiet," by the Birdwing label, 1989, ASIN: B000008LD5. Permission sought.

4. Egon Sendler, *The Icon: Image of the Invisible* (Redondo Beach, CA: Oakwood Publications, 1998), 107.

5. Sendler, *The Icon: Image of the Invisible*, 110–12.

6. S.V Timchenko, *Russian Icons Today: Album of Reproductions, Sketches Sovremennik*, 1994 (ISBN 5-270-01477-7)